University of Tehran Science and Humanities Series

Series editor

University of Tehran, Tehran, Iran

The *University of Tehran Science and Humanities Series* seeks to publish a broad portfolio of scientific books, basically aiming at scientists, researchers, students and professionals. The series includes peer-reviewed monographs, edited volumes, textbooks, and conference proceedings. It covers a wide range of scientific disciplines including, but not limited to Humanities, Social Sciences and Natural Sciences.

More information about this series at http://www.springer.com/series/14538

Hossein Bahrainy · Ameneh Bakhtiar

Toward an Integrative Theory of Urban Design

Hossein Bahrainy
Faculty of Fine Arts
University of Tehran
Tehran
Iran

Ameneh Bakhtiar
University of Arts
Isfahan
Iran

ISSN 2367-1092 ISSN 2367-1106 (electronic)
University of Tehran Science and Humanities Series
ISBN 978-3-319-32663-4 ISBN 978-3-319-32665-8 (eBook)
DOI 10.1007/978-3-319-32665-8

Library of Congress Control Number: 2016937353

Printed on acid-free paper

This Springer imprint is published by Springer Nature
The registered company is Springer International Publishing AG Switzerland

Preface

A new field of the study (or an agglomerate of the old ones) has been emerging in the United States and in other countries since the turn of the last century. This is the field of 'urban design'. Increasingly, however, questions have been raised by academicians, theorists, and professionals concerning the essence, legitimacy, knowledge base and content and methods of inquiry of the field. Lynch (1984), for example, considers city-design as an artistic activity, and based on the way it was taught and practiced in early 1980s calls it as 'immature arts'. Sorkin (2007, 2009), in two controversial statements on the status and fate of urban design states: Urban design has reached a dead end. To justify his claim, he continues: Estranged both from substantial theoretical debate and from the living reality of the exponential and transformative growth of the world's cities, it finds itself pinioned between nostalgia and inevitabilism, increasingly unable to inventively confront the morphological, functional, and human needs of cities and citizens. While the task grows insurgency and complexity, the disciplinary mainstreaming of urban design has transformed it from a potentially broad and hopeful conceptual category into an increasingly rigid, restrictive, and boring set of orthodoxies. Cuthbert (2007) believes that traditional Urban Design 'theory' is anarchistic and insubstantial in the sense that there is no cement binding the pieces together. This is, according to him, the situation, which has been ongoing for the best part of 50 years, offering unprecedented opportunity for debate and resurrection.

Cuthbert (2007) suggests that the discipline of urban design should not seek to justify its existence through any of the normal channels adopted by mainstream theory. It should avoid the vain attempt to generate an internally coherent theory and instead reorient its efforts to making connections with social science through the mechanism of political economy, a synthesis discipline which already has a history of two and half centuries. Here in this book, however, the synthesis discipline is language with a much longer history and better qualifications to represent knowledge and construct an integrative theory.

In many ways, however, the practice of urban design today may be more widely recognized in the public and private sectors as a source of potential solutions to urban problems than it has been over the past 50 years (Soja 2009; Schurch 1999). This is the case, where confusion as to the content, purpose, knowledge base, and tools of urban design has influenced its adequacy and effectiveness. In this regard Madanipour (1997, 2004) claims that, in spite of growing attention to the subject and the rising number of academics and professionals who are engaged in urban design and widespread popularity, the term is still suffering from ambiguities. Dualities of scale (macro vs. micro), subject emphases (visual vs. spatial and spatial vs. social), process versus product, public versus private, objective-rational versus expressive-subjective, and also discipline versus interdisciplinary activity are of major concern to the members of the society and others.

Inam (2002), criticizing the contemporary urban design as a vague, superficial, and product-oriented field, because it is an ambiguous amalgam of several disciplines, including architecture, landscape architecture, urban planning, and civil engineering; obsessed with impressions and esthetics of physical form and is practiced as an extension of architecture. He then concludes that urban design lacks a clear definition (and hence, a useful understanding) and a clear direction (and hence, a useful purpose). Lang (2009), while believing that of all the design fields, urban design has the greatest impact on the nature of cities and city life, regards the term 'urban design' as confusing.

The illusiveness of its definition raises significant debate about exactly what urban design is? From 'large-scale architecture' to 'project-scale design', to architecture and urban design are but a single profession. Design is at the heart of these efforts', 'an extension of architecture', 'urban design is not architecture. The function of urban design, its purpose and objective, is to give form and order to the future. As with the master plan, urban design provides a master program and master form for urban growth. It is primarily a collaborative effort involving other professionals (Marshal 2009). Since the late 1860s, urban design as a discipline has flourished, and in recent years the ideal of the synthesis of architecture, landscape architecture, and planning in the three-dimensional design of urban environments has returned as a key organizing concept for many designers in the field. A new interest has emerged in the theoretical basis of this synthesis (Mumford 2009).

In recent years, the field's physical scope and content and the way it touches the human experiences have expended and also the kind of people with whom urban designer joins forces has grown significantly (Brown et al. 2009).

Some 30 years ago Jonathan Barnett (1981) made this critical statement that nothing is more frustrating than to watch the continuous misapplication of huge sums of money that are spent in rebuilding of our cities and developing the countryside. Thirty years later he rephrased his concern by stating that the world is urbanizing faster than current city-design can keep up; refer to three challenges of rapid urban change, climate change, and natural and man-made disasters (Barnett 2011).

By addressing these fundamental issues, this book intends to, through an epistemological approach, first identify the potentially unique knowledge base of the field of urban design, and then introduce an appropriate medium to construct urban design theory in a way to properly and adequately represent that knowledge base. This knowledge base, which is represented here through its language, has been sought in relation to the genuine goals and purposes of the field of urban design as they have been historically established and are currently modified on the basis of the contemporary needs and desires of society. This knowledge base consists of two distinctive areas: substantive and procedural elements. Substantive elements consist of urban form and space, and urban activities, while procedural elements consist of intuitive and scientific methods. Urban design, as proposed here, is the application of these integrative rules and principles (as grammar) to substantive elements (as vocabulary) in order to establish order in the physical environment (see Alexander 1992, pp. 94–98). This may be considered as a plausible approach to develop a general theory for urban design (Figs. 1 and 2).

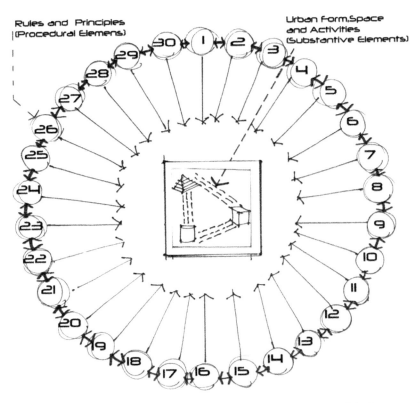

Fig. 1 The interrelationship of the procedural and substantive elements of the language of urban design

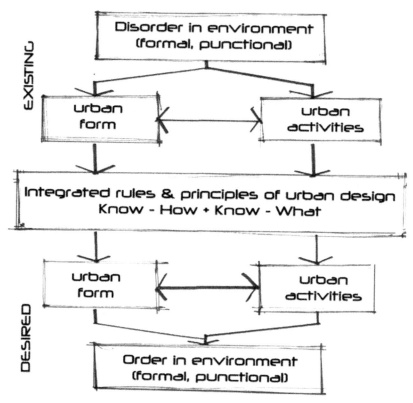

Fig. 2 Integrated rules are applied to the disordered environment, manipulating its elements to establish order

Contents

2.1 Urban Design Definition

One can possibly find as many definitions for urban design, as the number of writers and practitioners of urban design (see for example: Pittas 1980; Floyd 1978; Lynch 1981, 1984; Mackay 1990; Gosling and Maitland 1984; Tibblads 1984; Gosling 1984a, b; Barnet 1982; Colman 1988; Goodey 1988; Levy 1988; Scott Brown 1990; The Pratt Institute Catalogue 1988; Kreditor 1990; Lang 1994, 2005; Relf 1987; Madanipour 1997; Schurch 1999; Marshal 2009; Brown et al. 2009; Mumford 2009). These varieties of definitions, aside from some commonalities, reveal the very complex and multi-dimensional nature of the subject matter of urban design. Schurch, in analyzing some of these definitions, suggests that the fundamental problems with these definitions of urban design are that they lack breadth, cohesion and consistency (Schurch 1999, p. 17). Over thirty years ago Pittas (1980) emphasized on the importance of a clear definition to the success of the profession. He, then, suggest seven parameters that urban design deal with: (1) enabling rather than authorship; (2) relative rather than absolute design products; (3) uncertain time frame; (4) a different point of entry than architecture; (5) a concern with the space between buildings; (6) a concern with the three dimensional rather than two dimensional, and (7) principally public activity. Tibbalds (1984) believes that there is no easy, single, agreed definition of urban design.

Madanipour (1997) claims that urban design is a far from clear area of activity. He further adds that signs of the need for a clear definition of urban design can be seen in a variety of sources. Here we give only a few examples. Kreditor (1990) suggests that if one doubts the immaturity of urban design as a serious field of study, the search for a common definition or understanding of the term will be instructive, for there is none. He further adds that a lack of shared meaning undermines appreciation and retards development. Cuthbert (2007) reflects his frustration with urban design definition when he calls it the endless problem of 'defining' urban design. To Kreditor urban design is the institutionalization of our search for good urban form. It transcends visual perception. It is concerned with pleasure as well as performance, and it embraces traditional design paradigms with city building process (Kreditor 1990, p. 157). Some still have doubts as to the nature of urban design as a scientific or artistic field of inquiry. Kostoff, for example, maintains that urban design is of course an art, and like all design it does have to consider, or at least pay lip service to, human behaviors (Kostoff 1991, p. 9). Moughtin (1999) takes the same position when defines urban design as the art of city building, which concerned with the method and process of structuring public space in cities (Moughtin 1999, p. 1). But when he further describes the functions of urban design, he ignores that definition to state that any discussion of urban design which does not address

© Springer International Publishing Switzerland 2016
H. Bahrainy and A. Bakhtiar, *Toward an Integrative Theory of Urban Design*,
University of Tehran Science and Humanities Series, DOI 10.1007/978-3-319-32665-8_2

environmental issues has little meaning at a time of declining natural resources, ozone layer destruction, increasing pollution and fears of the greenhouse effect. In these circumstances any discussion of the aesthetics of city design in a pure or abstract form unrelated to environmental concerns could be described as superficial and rather like rearranging the deckchairs on the Titanic (Moughtin 1999, p. 1). There are also some who take a more pragmatic position by saying that urban design is what urban designers do. According to this view to know who is an urban designer is determined by appeal to historical and sociological criteria. Also the answer to the question of what constitutes good urban design, the pragmatist believe must come from the urban designer or the practices of urban design.

According to the Royal Institute of British Architects (1970) urban design is an integral part of the process of city and regional planning. It is primarily and essentially three-dimensional design but must also deal with the non-visual aspects of environment such as noise, smell or feelings of danger and safety, which contribute significantly to the character of an area. Its major characteristic is the arrangement of the physical objects and human activities which make up the environment; this space and the relationships of elements in it is essentially external, as distinct from internal space. Urban design includes a concern for the relationship of new development to existing city form as much as to the social, political and economic demands and resources available. It is equally concerned with the relationship of different forms of movement to urban development (see Gosling 1984a, b, p. 7). But while RIBA's definition is comprehensive, Banham's is too narrow and specific, at least with regard to the scale. Banham suggests that the intermediate field of urban design is concerned with urban situations about half a mile square (Banham 1976, p. 130). It seems that Banham's definition of urban design is in fact large-scale architecture, and would most likely deal with single design problems, single use, single contractor, and most important takes place in the private sector. Social, economic and environmental problems are pressing forces in almost all cities around the world, regardless of their level of development, etc. Pollution (air, water, soil, visual,...), traffic, waste management, overcrowding, injustice, poverty, crime, alienation, segregation, housing shortages,... urban sprawl, blight are common problems in all cities everywhere.

Gosling (1984a, b) suggests that urban design is concerned with the physical form of the public realm over a limited physical area of the city and that it therefore lies between the two well-established design scales of architecture, which is concerned with the physical form of the private realm of the individual building, and town and regional planning, which is concerned with the organization of the public realm in its wider context (Gosling 1984a, b, p. 9). So it further becomes clear that urban design deals essentially with public realm, but its subject matter requires artistic, as well as scientific approaches. Its content includes social, economic, demographic, environmental, aesthetic, physical, spatial and symbolic values, both as substances and procedures of urban design. Economic factors are extremely powerful determinant of land use patterns, density, and urban from. The form of today's city tends towards three dimensional representation of land values. Overcrowding, injustice, lack of safety and security, crime and violence, frustration, alienation, isolation, segregation, delinquency, inequality, blight, social stratification have their roots in the economic, social and demographic factors. Beautification is probably the oldest aspect of city design, which is relatively well understood, not only by designers and authorities, but also by the layman. The same is also true with engineering factors, such as traffic engineering and infrastructure, simply because they are functional and their role can be understood by all users, and any deficiency in these elements is clearly reflected in the overall functioning of the city. Along with, and as a consequence of, urbanization and industrialization environmental and ecological issues have become increasingly critical in any urban design decision.

Political, technical, technological, as well as cultural and behavioral issues are also significant forces in urban design. As we saw the city, its inhabitants and functions are extremely complicated phenomena whose problems interact in complex ways. Now this constitutes the context and the subject matter of today's urban design.

Addressing some of the problems in defining urban design, Anne Vernez-Moudon describes concentrations of inquiry in this field, including urban history studies, picturesque studies, image studies, studies of environmental behavior, place, material culture, topology-morphology and nature ecology, and provides a useful list of major contributors in each area (Vernez-Moudon 1992, pp. 331–49).

Richard Marshal (in Krieger et al. 2009) suggests this definition for urban design in 'The Elusiveness of Urban Design': "Urban design…is a 'way of thinking.' It is not about separation and simplification but rather about synthesis. It attempts…to deal with the full reality of the urban situation, not the narrow slices seen through disciplinary lenses." In the same direction Douglas Kelbaugh defines Urban Design as an art not a science or an engineering discipline, but a social and public art…Unlike a painter or sculptor, in every aspect of my work I am responsible not only to myself, but to my fellow man and to future generations (cited in Brown et al. 2009, p. 4). These open-ended, nonhierarchical stances are especially important for the new approach proposed in this book. Urban design may be regarded as an art or technical practice involving the physical organization of buildings and spaces, towards a civic purpose (Marshall 2012).

2.2 Existing Urban Design Knowledge Base

Any investigation of the knowledge base requires the study of the theory of knowledge. The theory of knowledge, or what is known in philosophy as *epistemology*, deals with fundamental questions that arise in conjunction with the emergence of a new study area, or of an already established one that is developing. Questions such as the

legitimacy of the field, nature, characteristics and components of its knowledge base, its methods and approaches and finally its jurisdiction and its relationship with other areas and fields are examples. These are the important issues in any field, including urban design, which give an idea of the subject a particular field deals with, the body of knowledge it has constituted and the tools one may employ to possess the field and be able to communicate in it. Clarification of these issues will define the field and set its boundaries. Lack of such a clarification, on the other hand, will result in confusion, frustration, and inefficiency in the professionals' and practitioners' efforts to achieve urban design goals.

Though urban design is the most traditional field of planning, it sorely lacks cohesive theoretical foundations. Much writings takes the form of guidebooks or manuals, which rely on rules of thumb, analytical techniques, and architectural ideas whose theoretical justifications are unclear. At best we have a number of contending approaches, such as Formalism and New Urbanism, which tend to operate in a theoretical vacuum, as if cut off from larger streams of planning thought, and to invite dogmatic adherence (Sternberg 2000, 265).

The contemporary practice of urban design, according to Barnett (2003) began in the 1960 as reaction against the failures of modernism to produce a livable environment. To make cities more livable, urban designers countered modernist ideology by protecting historic buildings, by making the street the primary element of urban open space, and by using zoning and other development regulations creatively to put new buildings into context and preserve a mix of different activities (Barnett 2003).

Most of the existing urban design literature is on urban form and its attributes. Some urban geographers (Scargill 1979; Foley 1964), for example, have looked at urban form from morphological point of view, i.e., its physical fabric, office and manufacturing functions, and the assemblage of structures that are the spatial expression of urban phenomena, such as economic, social and political processes. Efforts have also been made to develop appropriate tools

and methods which the physical environment can be explained, analyzed, recorded and designed effectively, systematically and rationally. The majority of these methods deal with the relationship between man and his environment, and the perceptual and visual aspects of urban form.

Among various efforts made in this regard, Kevin Lynch's works are especially distinct. His well known book, *The image of city* (Lynch 1960), for example, is a tightly woven argument moving between concepts of perception and real-world research resulting in an explanation of how different formal aspects of the city design can be more or less manifested in the environment.

For Kevin Lynch, the city designer had to deal with the experiential quality of the city, what he often called the "sensuous qualities" or simply "sense" of place (Bannerjee and Southworth 1991, p. 6).

In another effort called, *City design and city appearance*, Lynch (1968) suggests a general list of perceptual criteria to be used in the analysis and research of urban form. In a quite unprecedented effort, Lynch and Rodwin (1958) provide a significant analytical methodology for the analysis of urban form.[1] For a systematic analysis of urban form they suggest six criteria: Element types, quantity, density, grain, local organization and general spatial distribution. The exceptional value of this method is that for the first time an analytical method, and not a descriptive one, is used to analyze and understand the varied effects of different physical forms. The most significant contribution of Lynch, however, is his last book, *A theory of good city form* (1981), which as a comprehensive study on urban form, includes all his previous findings. The most distinctive part of this study, which seems to be the very core of the book, is the normative criteria for the evaluation and analysis of urban form. *Wasting away* by Kevin Lynch (1991) is in different direction than his previous works. It is a dark study showing a growing recognition that decay and waste are a necessary part of contemporary life. A collection of Lynch's remaining unpublished work was published in 1990 with great efforts of Tridib Bannerjee and Michael Southworht: *City sense and city design: writings and projects of Kevin Lynch.*

In a related but different context, Thiel (1961) has created a 'space score' which organizes the physical forms perceived by a person in motion as he/she changes speed and direction. Thiel is one the most significant contributors of notations, perception, communication and participation in design. His major work: *people, paths and purposes* (Thiel 1997), which is based on extensive study of over forty years, covers all these areas. Appleyard et al. (1964) have also built upon this technique, placing the elements seen along a highway into such a 'score' as a way of developing techniques for communicating both orientation to place and the experience of the person in motion in relation to his surroundings. Halprin (1964) has established another technique for recording a behavior circuit. Appleyard's work, *Livable streets* (1981), provides a broad range of techniques for the evaluation and analysis of streets, neighborhoods and their components. Kostoff, through his tow remarkable books (*The city shaped* 1991; and *The city assembled* 1998) made a great contribution to the analysis of urban patterns.

Katz (1994) gives an explanation of the principles of the new urbanism, with twenty-four case studies include the best-known and perhaps most controversial development of the new town of Florida, Seaside. In his "City of bits", published in 1996, William J. Mitchell described a new vision of urban living. The use of the new communication technology will have profound impact on space and time relationship and eventually the future shape of our cities.

Two other most important and valuable efforts in this regard are Foley's, *An approach to metropolitan spatial structure* (1964), and Webber's *The urban place and the nonplace urban realm* (1964). The result of Foely's efforts is a valuable conceptual framework that seeks to

[1]In regard to normative aspects of urban form, for example, Lynch has suggested the following seven criteria, five of which he calls performance dimensions and two meta criteria: Vitality, sense, fit, access, control, efficiency, and justice. Kevin Lynch, *A Theory of Good City Form* (Cambridge, Mass: MIT Press, 1981).

bridge spatial and aspatial aspects and values and the physical environment.

Among other designers who have contributed to the development of methods to analyze and synthesize urban form several others are worthy of mention: Sitte's *The art of building cities…* (1945), Alexander's *Notes on synthesis of form* (1964), *Pattern Language* (Alexander et al. 1977) and *A* new theory *of urban* design (1987), Venturi's *Learning from Las Vegas* (1977), Steinitz's *Meaning and the congruence of urban form and activity* (1968), Crane's *City Symbolic* (1960), Mitropoulos' *Space network: Toward a hodological design for urban man* (1975), Choay's *Urbanism and semiology* (1975), Bogdonovic's *Symbolism in the city and the city as symbol* (1964), and Tugnutt and Robertson's *Making townscape* (1987).

In Camillo Sitte's classic work *City Planning According to Artistic Principles* (1965, first published in Vienna in 1889) and much later in Edmund Bacon's *The Design of Cities* (1974), good urban design was to be based on artistic principles of *good form*. Though in each of their works "art" is sometimes meant in the romantic sense as the exercise to the artist's inscrutable genius, at other points, and more importantly for present purposes, art also reflects principles that can be explicitly communicated (Fig. 2.1). These principles are based on the geometry of visual perception, the scale of beholder's body, and the continuity of the beholder's experience.

We can best understand the implications by looking at Sitte's major concern, the urban plaza. The underlying principle is that the plaza should

be made into a cohesively observable whole. It is in this respect that we should understand Sitte's dictum about proportion. He further asserts that a noteworthy building that is taller than wide should receive a deep plaza, while a building that is wider that tall would benefit form a wide plaza. Though these rules of proportion may seem arbitrary, they reflect an implicit theory about the cohesiveness of the beholder's experience of the plaza (Sternberg 2000, pp. 268–270).

Edmund Bacon (1974) adds a number of additional guides to good form, demanding that good design should interlock and interrelate buildings across space. Bacon stresses that the human experience of this articulated space happens along an axis of movement. To define this axis, the designer may strategically place small and large buildings to create scale linkages receding in space; or insert in the landscape on arch, gate, or pair of pylons that set the frame of reference for structures appearing on a recessed plane (Sternberg 2000, p. 271).

Christopher Alexander was committed to the social nature of built space. His research in the 1960s was dedicated to finding ways of configuring social forms and relationships spatially. In his books of 1970s, he reverted to a humanism, similar to that of Mumford's 1950s writing. In particular, what emerged in *A Pattern Language* (1977) was his commitment to the view that the value of architecture is in its capacity to enable individuals to realize their collective existence as social beings.

The vocabulary Alexander used to describe this, is interesting. "Towns and buildings", he writes, "will not be able to become alive, unless they are made by all the people in society, and unless these people share a common pattern language"(x) (Alexander et al. 1977).

There are, however, increasing number of theorists who explicitly oppose to Alexander's *Pattern Language* on the grounds of impracticality, lack of test, etc. (see for example Moudon 1992, 2000).

On the other hand Dutch architect Hertzberger (1991) suggests that just as mankind is distinguished by its use of language, so too does mankind have the facility to adopt and give

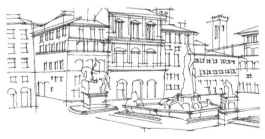

Fig. 2.1 Florence, Piazza of the Signoria. The relationship between buildings, monuments and public squares (from Sitte p. 9)

meaning to spaces, like language, this is not something that can be controlled by anyone individual, but is negotiated socially. This led Hertzberger to be strongly influenced by phenomenology, and the assumption that architecture is a means to revealing what it is to be in the world as a social being.

Hertzberger's descriptive language is borrowed in part from linguistic theory–hence his liking for "structure"–but in all other respects it is heavily reliant on the conventional modernist vocabulary: "form", "function", "flexibility", "space", "environment", "articulation" and "users" are recurrent words.

Forty (2000) by questioning the capability of language in two respects: (1) Limitation to describe the "social" aspects of architecture and (2) not having the capacity to show the relationship between social practice ad physical space, has put together a series of characteristics as words or vocabulary of modern architecture.

As we know, the relationship between architecture and verbal language has not been much talked about, even though, as one architectural theorist, Tom Markus, recently pointed out, "language is at the core of making, using and understanding buildings" (Markus 1993). Forty (2000) suggests the following characteristics as the vocabulary of modern architecture: Character, context, design, flexibility, form function, history, memory, nature, order, simple, space, structure, transparency, truth, type and user. Obviously, these are too general and vague to be of any use in architecture–building meaningful and purposeful buildings.

Christopher Alexander (Alexander et al. 1987) in his "A new theory of urban design", along with his five other books, has claimed to have provided a complete working alternative to the present ideas about architecture, building, and planning. He has considered the laws of wholeness as the main quality of urban design. The task of creating wholeness in the city, according to Alexander, can only dealt with as a process, i.e., the centering process. To achieve this goal he postulated one overriding rule–wholeness, and seven rules of: piecemeal growth, the growth of larger wholes, visions and the basic rule of positive urban space,

layout of larger buildings, construction and formation of centers. Heburther suggests that urban design as "process" may be taken, in the economic sense, as the response to the power of economic forces shaping the structure of the city not as a physical end but rather as part of a dynamic process. Alexander maintained that it was the process, above all, which was responsible for wholeness, not merely the form. This "wholeness", Alexander said, can be provided by the definition of a number of geometric properties with a centering process.

Gosling (2003) reviews the historical development of the discipline and practice of urban design in America during five decades of 1950 to 2000. Other efforts in this respect are: Gosling and Maintland's *Concepts of urban design* (1984), Cullen's *The concise townscape* (1971), Row and Koetter's *Collage city* (1978), Krier's *Urban space* (1979) and *Leon Krier: Architecture and urban design 1967–1992* (1992), Aravot's *From reading of forms to hierarchical architecture: An approach to urban design,* Broadbent's *Emerging concepts in urban space design* (1990), Tibbalds's *Making people-friendly* towns (1992). Calthorpe (1989) has suggested what he calls simple clusters of housing, retail space and offices within a quarter mile radius of transit station. Lang (1994) makes an attempt to unite architecture and city planning, and also enhance urban designers' graphic and verbal communication skills. According to Lang contextual design is the most important element in urban design because without context, the city becomes fragmented. Lang examines the social and environmental issues within the context of American urban history. Lang proposes four types of urban design: The urban designer as a total designer, all-of-a-piece urban design, urban designer as the designer of infrastructure, ad urban designer as designer of guidelines for design. Barnett (2003) states that urban design requires a different process from designing a landscape or building (a process involving government, communities, investment and entrepreneurs). According to Barnett urban designer should have enough knowledge of the social sciences to be able to make diagnoses about the social dynamics of the community. Barnett's main idea is urban design as public policy (1874 and 1982), he later

suggests five principles as the basic principles for city design: community, livability, mobility, equity, and sustainability (Barnett 2003). Gosling (2003) has called the techniques used by Cullen theories of the picturesque or theory of 'social vision'—sequential three-dimensional experience by moving through the city and annotating these experiences in the form of sequential perspectives.

Hedman (1984) suggests that to achieve design unity involved the establishment of seven rules: building silhouette; space between buildings; setback from street property lines; proportions of windows, bays and doorways; massing of building form; location and treatments of entryways; surface material; finish and texture; shadow patterns from massing and decorative features; building scale; architectural style; and landscaping. Hedman regards conceptualism as one of the current trends in urban design.

Postmodern Urbanism (Ellin 1996) covers variety of writers of urban studies of the 20th century, e.g.: Katz, Peter calthorpe, Robert Venturi, Charles Jencks, Denise Scott Brown, Elizabeth Plater-Zyberk, Doug Kelbaugh, Frank Gehry, Richard Sennett, Michael Graves, Paolo Portoghesi, Peter Blake, etc.

In an ambitious, but interesting paper, Sternberg (2000) has proposed "an integrative theory of urban design". He, then, identifies the integrative principles through which urban environments can transcend commodification. The principles are: good form, legibility, vitality, and meaning. He further also adds comfort to these principles.

Sternburg points out that since all these capacities to experience are combined in one beholder, the designer's task is that of integrating them through the principles of composition. Sternberg suggests foremost among these principles of composition is *continuity*. According to Sternberg, participant's experience of the city coheres according to several integrative principles, which can be understood separately or in combination. Nodes and enclosure, fine grain and ascent into space, mixed use and myth, permeability and relative proportion—guided by explicit integrative principles, the urban designer

must compose across experiential domains to produce a continuity of experience (Sternberg 2000, p. 275). Sternberg uses five criteria to be met by his integrative theory: being inclusive, substantive, based on human experience of built form, commodifiability as well as uncommodifiability, and to guide practice.

Without going into a lengthy discussion on the plausibility and validity of Sternberg's claim on the integrative theory of urban design, a few critical questions may be raised: (1) Isn't the Lynch's suggested theory in *good city form* more inclusive and practical than Steinberg's? (2) as an integrative theory it does not deal with procedural issues, (3) the principles suggested are not actually principles, but goals of urban design., (4) there are many other goals which could be included in the list, such as: safety, security, accessibility, environmental sustainability, etc., (5) and most of all the proposed theory does not really do what a theory is expected to do for the members of the discipline, as well as for practitioners. All these problems might be referred to the kind of definition Sternberg gives for urban design and its knowledge base: "*the human experience that the built environment evokes across private properties or in the public realm*", which is too general and vague and does not serve any specific purpose.

Claiming its roots in the history of theory, the New Urbanism first exercised its influence by building a supporting base in design practice. It later added pedagogical dimension, with educational programs at the University of Miami and in the Congresses (Moudon 2000, p. 42). New Urbanism has gained prominence as an alternative to traditional U.S. suburban design, through comprehensive urban design and planning, New Urbanism seeks to foster place identity, sense of community and environmental sustainability. New Urbanism began as a modest experiment in the 1980s, since then, its influence has grown significantly (Day 2003, p. 83).

At the neighborhood level, New Urbanists recommend that mixed uses (commercial, civic, residential, public spaces, and other) be incorporated in each community. The goals are to

provide jobs near where people live and allow residents to walk or bicycle to the places they need to go. Similarly new urbanists recommend that neighborhoods incorporate alternative forms of transportation to decrease auto dependence. The Charter further recommends that neighborhood design should reinforce the unique identity of each place by adopting a consistent and distinctive architectural style that draws on local history, culture, geography, and climate (Congress for the New Urbanism 2000).

New Urbanism's highest profile "urban" projects include the HOPE (Housing Opportunities for People Everywhere)IV renovating of public housing. HOPE IV strives to reduce the connection of poor families in public housing and to develop neighborhoods with residents of different economic and racial/ethnic groups.

The main principle (goal) is clearly stated by New Urbanists is *design for diversity*. New Urbanism promotes the end of segregation between rich and poor (Congress for the New Urbanism 2000).

Day (2003), analyzing the New Urbanism's goal of designing for diversity raises several concerns: First, physical changes may not be the best solution for the social problems these neighborhoods may face. Furthermore, New Urbanism ideas—"mixed use," public space, "and so on—may conjure different meanings for different groups in the neighborhood. At the same time, New Urbanist renovation may displace low-income residents from the neighborhood. Finally, New Urbanist participatory design processes may not accommodate diversity.

Moudon (2000) on the other hand, seems to be in support of the New Urbanism when she states that "as a theory, New Urbanism is notably and refreshingly free of the grand statements and obscure rationale typical of many urban design theories. As a movement, its focus is practical and didactic, providing simple, clear and hand-on directions and guidelines for designers, planners and builders making towns" (Moudon 2000, p. 38). But as she points out, it validity as an urban design theory is to be investigated: "A logical next enabling step would be to develop a research program that would establish a substantive foundation that would test and validate the movement's ideas, ground it into actual processes of city building and contribute to its long-term viability (Moudon 2000, p. 42).

Besides the designers, there have also been experts and specialists from other areas and disciplines who have tried to develop methods and theories for their own use and also for the use of designers. Among these non-designers are behavioral scientists such as Maslow (1957), Mayo (1946) and sociologists such as, Sommer (1969), Rosow (1974), Hall (1959) and Michelson (1970, 1975). Among these the efforts of Michelson to develop a new approach for environmental design is especially valuable. Among this group there is Amoss Rapoport, who is the leader in his efforts to delineate the relationship of man and environment. His major contributions are *Complexity and ambiguity in environmental design* (1967), *Human aspects of urban form: Towards a man-made environment approach to urban form and design* (1977), and *The mutual interaction of people and their built environment: A cross-cultural perspective* (1976).

There are also behaviorists such as: Francis 'Mapping downtown activities (1984), Hubbard's *Environment-behavior research—a route to good design* (1992), and Whyte's *The social life of small urban spaces* (1980) who, by linking behavior patterns to space, have tried to find a legitimate base for rational urban design.

A group of researchers at the University College London have been working on space syntax, which is best described as a research program that investigates the relationship between human societies and space from the perspective of a general theory of the structure of inhabited space in all its diverse forms: buildings, settlements, cities, or even landscapes. The point of departure for space syntax is that human societies use space as a key and necessary resource in organizing themselves. In doing so, the space of inhabition is *configured*—a term that space syntax recognizes as an act of turning the continuous space into a connected set of discrete units (Bafna 2003, p. 17).

2.3 Contemporary Urban Design Movements and Their Rules and Principles

Last century witnessed the emergence of variety of urban design movements, their common purpose which was to save the city and its quality against the adverse impacts of industrialization. It is obvious that the movements have the same roots in urban planning as in urban design, and for the most recent ones the implication for urban design is to be seen in the future. Each movement is based on certain rules and principles, which will be reviewed briefly.

2.3.1 Park Movement

Park Movement was created as a response to the deteriorating conditions of American cities in 19th century. The movement was based on the revival of the relationship between man and nature. When Barron Haussmann was busy with the urban renewal of Paris, Frederick Olmsted founded the Park Movement in the United States. The success of Olmsted in building Central Park in New York made him the prominent landscape architect of his time.

One of the fundamental principles of this movement was establishing parks in order to preserve breathing space for the future of cities. The second important principle was an effort to connect city life with life in nature. Organic forms and design, rather than geometrical shapes, natural green spaces and lakes were the dominant elements used under this movement (Figs. 2.2, 2.3 and 2.4).

Fig. 2.3 Central Park in Manhattan, the first real experience of the park movement, by Olmsted

Fig. 2.4 The kind of scenes in Western cities which led to the creation of park movement

2.3.2 City Beautiful Movement

Sitte (1945) criticizes modern city planning as lacking artistic taste and regards city design as civic art. She has a romantic three-dimensional view for the city, applying a mix of classical Greek, Rome Empire, Italian Renaissance, Paris Haussmann and Beaux Arts, as neo classicism style of architecture. "Good of the Whole" was the motto of the movement to produce unity and

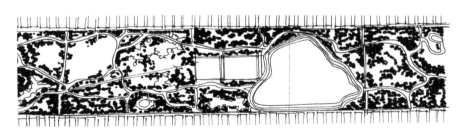

Fig. 2.2 Central Paris as one of the greatest scheme of the city beautiful movement (Brown et al. 2009, p. 6)

cohesion between the urban components and elements. Balanced relationships between these elements is regarded as beauty.

City center is the dominant element of urban design and the core of the physical and cultural aspects of the city. The centre is connected by roads from all sides, visually and physically. Public spaces are the identity of the city.

It is, however, Daniel Burnham who played the key role in introducing the Movement to the world. His vision of the city design is summarized in the following statement:

> men's blood and probably will not be realized. Make big plans, aim high in hope and work, remembering that a noble, a logical diagram, once recorded will never die...

Daniel Burnham's more widely known 1909 City Beautiful Plan for Chicago, with a grand boulevard system overlaid on local streets with great waterfront parks and civic buildings, influenced city development throughout the twentieth century. Movement's principles are: Urban design as civic art, balance between urban elements to create a unified and cohesive unit, city center is regarded as the dominant urban design element and the physical and cultural center of the city, visual and spatial connection of all city roads to the center create a unified and centralized structure, good of the whole, geometrical forms and order.

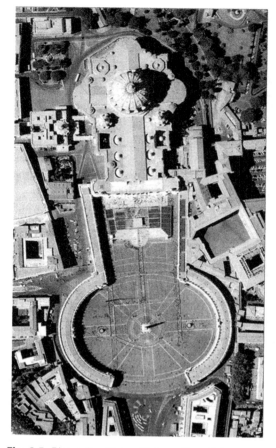

Fig. 2.5 Piazza San Pietro, Vatican City, 17th century, as the origin of city beautiful movement (*Source* Brown et al. 2009)

2.3.3 Garden City and New Town Movements

Ebenezer Howard proposed the landmark garden city concept in 1898 that included self-contained, self sufficient communities surrounded by greenbelts. Howards's vision influenced several generations of urban designers in Europe and the United States, including many elements of contemporary new urbanism movement (Figs. 2.5, 2.6, 2.7, 2.8 and 2.9).

At the macro scale, garden city was based on two principles: one to draw urban life into the

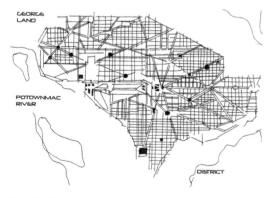

Fig. 2.6 The pattern used by L'Enfant for the plan of Washington, D.C. (*Source* Morris 1979)

Fig. 2.7 The pattern used in the reconstruction of part of London which was damaged by fire in 1666 (Morris 1979)

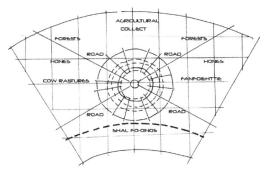

Fig. 2.9 Howard's diagram of the Garden City (Fishman 1977)

Fig. 2.8 Central Paris as one of the greatest scheme of the city beautiful movement (Brown et al. 2009, p. 6)

countryside, in order to create an environment that combines city life advantages with the rural beauty and this new settlement will replace

existing cities. The second principle was decentralization. At the micro scale Howard believed in two principles of unity and symmetry. Although Howard's Garden City did not succeed in application, it had significant influence on the future movements of city planning and urban design, including new town movement, urban village, etc (Figs. 2.10 and 2.11).

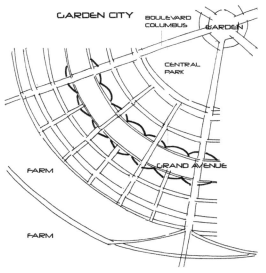

Fig. 2.10 Diagram details for a proto-typical Garden City—ward and Centre of Garden City–proposed by Howard, as the main component of the Garden city. School is located at the core of the neighborhood, where is connected by a pedestrian Grand Avenue (*Source* Dixon et al. 2009)

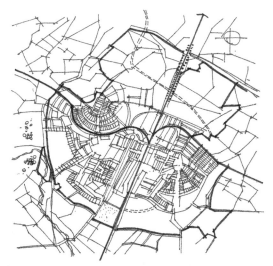

Fig. 2.11 Welwyn Garden City, diagram of general town plan (Neal 2003)

2.3.4 Modernism

Modernism is the only movement in the 20th century to grow and expand to become a universal school of thought. Several different factors justify this major shift: John Maynard Keynes's ideas introduced economic justification, doctrine of Luther on Protestantism provided religious justification, international expos, introduce experimental justification, reconstruction of the post-war Europe, was practical justification and cross subject application (in arts, literature, architecture, and city planning) contributed to its universalization. The new science and technology prepared the context for all these changes. Various thinkers and theoreticians put these new changes in the context to introduce theoretical and philosophical justification for such a paradigm shift.

Modernism principles were based on hygiene, justice, modern technology, building materials and techniques, speed, form efficiency and the idea of form follows function, minimum aesthetics and avoiding decorative elements, ideal city, high density, master design, expressways, zoning, mass production and standardization (Fig. 2.12).

Fig. 2.12 A scale model of the plan vision, 1925, (Fishman 1977)

2.3.5 Megastructuralism

The most significant principle in mega-structural design is putting variety of elements and their relations in one point and one single building in order to all elements and relations benefit from each other. The proposed megastructure is free from surroundings and designed in a way to function independently.

Metabolism, mega-form and collective form (Figs. 2.13, 2.14, 2.15, 2.16, 2.17, 2.18, 2.19, 2.20 and 2.21).

The architecturally philosophical concept of metabolism dates back to 1960s. The leading figures at the start of the Metabolitic movement were Kenzo Tange and Kisho Kurokawa as well as Kiyonouri Kikutake and architecture critic Noborou Kawazoe. Their architectural approach linked the late modern, technologized New

Fig. 2.13 Waling City, as mega structure, By: Herron (1964)

Fig. 2.14 Metabolism, mega-form and collective form

Fig. 2.16 Mega structure, a model of new Yokohama

Fig. 2.15 Mega form, Moshe Safdi: habitat. A community of 25,000 (from Banz 1970, p. 108)

Brutalism with the concept of architecture as analogous to biology.

In 1960, Kurokawa, together with Kikutake, Fumihiko Maki, Mosato Otaka, and Kizoshi Awazu published a manuscript entitled 1960—A proposal for a new urbanism, which expressed the basic outlook of the group members: We regard human society as a living process (Taschen 2003) (Fig. 2.22).

The city is divided into two parts: essential and nonessential. The essential part (main structure) is fixed and stable in the short time, but the rest will continuously undergo changes. This will lead to a division of responsibility of the part of public and private sector.

2.3.6 Team X

Team X movement was emerged due to the inadequacy of architectural and urban design ideas that were presented in the framework of the legacy of modernism and also the dissatisfaction with the Garden City idea. Each generation should be able to have the desired form for its own place. The purpose was to find a new path and method: a new start. A different style and feeling. To know and feel today's patterns, desires, tools, transportation and communication modes in order for the society to achieve its goals. But the path to the future should be left open, because time changes everything. This was a practical utopian, and not a theoretical one. Clustering of residential units will produce meaning and lead to the dominance of man over his home. Human hierarchy should replace functional hierarchy of Athens Charter.

Fig. 2.17 Rome was built in a day, by Mark Copeland (1997)

City as a collective/public art. To revive the sense of feeling toward the environment. To eliminate the discontinuity of the city. Non-Euclidian thinking. The emphasis will be on differences, rather than commonalities. To build the spirit of the time. A new definition for the relation between man and his environment.

According to this movement urban design should follow an organic process, based on the main structure (backbone), which includes public utilities, and cluster city, hierarchy, twin phenomena (e.g. diversity vs. unity) concepts. The car is halted at the appropriate point, and vertical mechanical circulation is located at key pints in the scheme (Figs. 2.23, 2.24 and 2.25).

2.3.7 Symbolism and Semiology

The main ideas behind this movement are: Historical continuity of sign, uniqueness, spatial dominance, containing unique activity, containing

Fig. 2.18 Ciudad Lineal, a linear city capable of extension across land. By: Arturo Soria Marta (1892)

secondary features, sequence of signs, scale, location, context, preventing redundancy (Fig. 2.26).

2.3.8 Behaviorism

Giving priority to pedestrian movement in urban spaces, mix uses, involving space users in decision-making process and implementation, paying attention to human needs and characteristics are the principal ideas of behaviorism movement. One of the primary principles of this movement is creating the kind of urban space

terms of resources, absorption of waste and maintenance of life support serving such as temperature and protections against radiation. These resources are intrinsically of value to humanity and should not be 'traded' against the benefit of a particular development or a particular activity as a whole (Fig. 2.37).

Demand management: involves more subtle and responsive planning to meet basic objectives rather than some derived demand. Hence it is possible, for example, to reduce energy consumption by a variety of conservation and efficiency measures as an alternative to building new power station.

Environmental efficiency: means 'the achievement of the maximum benefit for each unit of resources and waste products'. This could be achieved increasing durability; increasing the technical efficiency of resource conversion; avoiding the consumption of renewable natural resources, water and energy faster than the natural system can replenish them. Closing resource loops: by increasing reuse, recycling, simplifying

and avoiding the need for resource use (non-renewable).

Welfare efficiency: expresses the direct equivalent of environmental efficiency and describes the objective of gaining the greatest human benefit from each unit of economic activity. It requires a much more diverse social and economic system with many more possibilities for satisfying lifestyle requirements than at present.

Equity: Environmental policies have the potential to deliver significant improvements in the quality of life, health and job prospects of the marginalized, dispossessed and socially excluded in the society. Even the narrow notion of physical sustainability implies a concern for social equity between generations, a concern that must logically be extended to equity within each generation (Smith et al. 1998, pp. 18–20).

Berke and Manta-Conroy (2000) propose three conceptual dimensions [System Reproduction, Balance between Environmental, Economic, and Social Values; and link local to global (and regional) concerns] and six operational

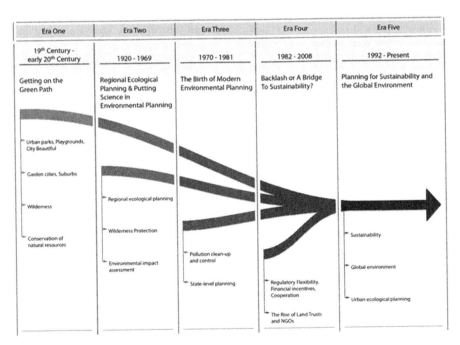

Fig. 2.37 The evolutionary trend of sustainability concept (*Source* Daniel 2009)

performances principles (harmony with nature, livable built environment, place-based economy, equity, polluters pay, and responsible regionalism) for sustainability. These principles are expected to play a key role in guiding evaluations by designers of the potential environmental, social, and economic impacts of urban forms and ensuring that design solutions integrate a balanced, holistic vision of sustainability (Berke 2002).

2.3.18 Urban Design for an Urban Century

Brown et al. (2009, 102–111) suggest five general urban design principles for what they call 'urban century', each of which is broken down into more specific guidelines:

Build community in an increasingly diverse society

 i. Create places that draw people together

 ii. Support social equity

 iii. Emphasize the public realm

 iv. Forge strongest connections

Advance sustainability at every level

 v. Forster smarter growth

 vi. Address the economic, social and cultural underpinnings of sustainability

 Expand individual choices

 vii. Build densities that support greater choice

viii. Build interconnected transportation networks

 ix. Provide choices that enhance quality of life

Enhance personal health

 x. Promote public health

xi. Increase personal safety

Make places for people

 xii. Respond to the human senses

xiii. Integrate history, nature, and innovation

xiv. Emphasize identity

 xv. Celebrate history

xvi. Respect and engage nature

xvii. Introduce innovation

A review of the contemporary urban planning and design movements and their relevant principles indicates that most of them are piecemeal and disintegrated ideas focusing solely on some aspects of the subject matter of urban design, often substantive issues, disregarding the rest. Integrative theory (language) of urban design, as will be proposed later, will include all aspects of urban design—substantive, as well as procedural. (For more information on contemporary urban design movements see: Bahrainy et al. 2006. Analysis of Contemporary urban design theories. Vol. 1: from late 19th century to 1970s. Tehran: UT Press).

Urban Design Theory

3.1 Proposed Integrative Knowledge Base of Urban Design

A review of the urban design literature indicated that so far no serious effort has been made to comprehensively identify the knowledge base of urban design. Rather, there have been some piecemeal and narrowly defined approaches and rules of thumb developed by individual professionals and theorists in special circumstances and for special purposes, which do not seem to qualify as the comprehensive knowledge base of urban design. Although urban design is seemingly embarrassed by a wealth of design theories, these seldom amount to anything more than statements of beliefs put forward by leading practitioners and academics in the field. Thus it appears that the theoretical basis for modifying the environment is impoverished in the extreme, and that there is little systematic positive theoretical basis for design practice (Lang 1987, 1994; Lynch 1984). From a British planner's perspective, writes Punter (1996), the short answer to the question as to whether urban design has an adequate theory is no! Punter presents many evidences for his claim.

For a study of the knowledge base of urban design, the analysis of these concepts seems to be relevant and necessary. Such an analysis is needed to justify goals and indicate the means to achieve goals and the tools to develop and learn the means. 'Means' are the knowledge and 'tools'

are the language of urban design. Both epistemological concepts deal with the very foundation of a field.

It is not surprising that some thirty years ago Pittas (1980) stated that most of the now disciplines came into being through the establishment of a set of governing paradigms which formed the theoretical underpinnings of discipline based knowledge. These paradigms, developed through the consensus of practitioners, are constantly tested and retested so that the theoretical underpinnings can and do change over time. He further believes that the first great leap into establishing a consensus among practitioners, researchers and educators of urban design has emerged and we can expect that a truly coherent discipline may evolve in the future.

Sommer (2009) poses a very critical question: Isn't the value of a professional or academic discipline—and urban design can be no exception—that it advances and curates a critical body of ideas and distills them into an array of methods and techniques that challenges entrenched assumptions and transform practices? For urban design to endure as a serious practice, it must claim, critically reassess and renew a discrete set of concepts that have evolved since the field first emerged as a discipline in the mid-twentieth century.

The universal need for order in the physical environment has established certain communal goals and desires within each society. An aggregate of these societal goals, desires and aspirations can be used as the overall purpose of urban

© Springer International Publishing Switzerland 2016
H. Bahrainy and A. Bakhtiar, *Toward an Integrative Theory of Urban Design*,
University of Tehran Science and Humanities Series, DOI 10.1007/978-3-319-32665-8_3

design—to identify the knowledge base of urban design and also to recognize its components. Urban design is defined here as the purposeful decisions and actions which aim at establishing functional and formal order in the physical environment. It is obvious that this definition implies some abstract and value-free elements such as the decisions and actions involved and the formal and functional orders sought. In fact, the nature, characteristics, and interpretations of these elements normally change from one context to another. They can, therefore, be defined specifically only in a particular context or culture.

It is intrinsic to this definition that urban design deals primarily with the *urban physical environment* which is the container of urban activities and hence, that urban activities, as the content, are also the concern of urban design; and that there are certain deliberate and purposeful decisions, actions and processes to be followed in order to achieve the desired goals. *Urban physical environment* in this definition implies urban form and all its attributes such as perceptual, visual and aesthetic processes, and *urban activities* refer to the systems of activities which involve individuals, groups and organizations in the urban environment. Urban design, therefore, deals with form as well function, and its purposes are efficiency as well aesthetics.

This general definition, which is based on the universal purpose of urban design, may lead us to the nature and components of the knowledge base of urban design. According to this definition, urban design concerns substantive areas, or the '*know-what*' of the knowledge base. Dealing with these substantive areas (i.e., understanding, explaining, [analysis], predicting, evaluating and synthesizing), requires certain tools, methods and processes which may be called procedural areas, or the *know-how* of the knowledge base. The knowledge base of urban design, therefore, consists of these two areas of *know-what* and *know-how,* which are reciprocal in nature.

In the substantive area, urban form deals with the objects in the urban environment–their distribution in space, their relationship with each other, and their relationship with man. The way of knowing that fits this area has to be holistic, subjective and qualitative. It involves an *intuitive* process. Urban activities, on the other hand, deal with all the economic, social, cultural, recreational and political activities of man in the urban environment. They aim at efficiency, justice and equity, which will eventually lead to the general welfare of the individuals in a society. In contrast to the elements and attributes of urban form, urban activities are normally quantitative, objective, and subject to measurement, decomposition and analysis. They, therefore, require tools, methods, and processes appropriate to dealing with these characteristics. They require a *scientific* method.

In the same way that urban form and urban activities are interwoven together and cannot be separated, so also are their methods and processes, i.e., intuitive and scientific methods. There are certain aspects of urban form, such as patternization, which may be explained and examined analytically and systematically through the application of scientific methods. There are also certain functional areas or stages in the analysis and decision-making processes of urban activities which require a holistic view of all the issues and parts which are simultaneously involved. This aspect of urban design can be dealt with by the *intuitive* method. The integration of intuitive and scientific methods which will provide a powerful tool of analysis and synthesis seems quite essential in urban design.

The Knowledge base of urban design consists of urban form, urban activities, and the integration of intuitive and scientific methods. Knowledge is intrinsically sporadic, complicated, ever-growing and unstructured. No one may possess or be sure to have possessed all the knowledge in one area. This is true in the case of 'urban design knowledge', where the diversity of the subjects involved and the interrelationships between them prevent one from knowing everything in the field. Language as an effective instrument of communication and representation, seems to be an appropriate tool for solving this problem.

3.2 What Is Theory and What Can It Do for a Profession?

Random House Dictionary of the English Language (1988) gives this definition for theory: a coherent group of general propositions used as principles of explanation for a class of phenomena: *Einstein's Theory of Relativity* (P. 1967). A theory, says Hanson, is a pattern of conceptual organization which **explains** phenomena by rendering them intelligible (Hanson in Suppe, p. 166).

According to instrumentalist view, theories are merely **instruments** which enable us to **deduce phenomena** from prior phenomena: a rule or a set of instructions (Suppe, p. 167). Theories have as their subject matter a certain range of phenomena and they are developed for the purpose of **providing answers to a variety of questions about the phenomena** in that range. These questions may include request for **explanations**, the **nature of regularities** among the phenomena, and so on. Theories provide the means for answering the questions by responding **generalized descriptions** for aspects of the phenomena. For a theory to be adequate not only must these generalized descriptions be true, but also they must be capable of answering the questions the theory is committed to answering (Suppe, p. 212).

Each theory carries with it its own standards of adequacy. Gibbs (1972) maintains that the primary criteria for assessing sociological theories is the **predictive** power.

Need for a "higher order" standards for assessing adequacy of theories.

Although it is said that there is no reason why the same standards should prevail for all theories, some claim that there should be certain common standards for assessing the adequacy of all theories—provide empirically true descriptions or at least be empirically confirmed by the facts (Suppe, p. 216).

These explanations, as Stroud points out, are general answer to questions, a "general way of knowing," through sense-perception (Stroud, 2000). No agreement seems to exist even between philosophers as to what qualifies as a clear-cut example of scientific theory. Some would maintain that the theories in physics are scientific, but those in sociology are not.

The job of a theory, according to Suppe, is to specify the expected patterns of behavior and to explain deviations from them. Theory presents an ideal of natural order—a principle.

It is characteristic of scientific theories that they systematize a body of empirical knowledge by means of a system of interrelated concepts (Suppe 1977, p. 64). Suppe regards theories as the vehicle of scientific knowledge (Suppe 1977, p. 3). The function of science, Suppe writes, is to build up systems of explanatory techniques; a variety of *representational devices*, including models, diagrams, and theories is employed to describe and reason about phenomena. According to Suppe, theories consist of ideals of natural order (which provide ways of looking at or representing phenomena), laws, and hypothesis which are stratified nondeductively via meaning relationships (p. 670). Theoretical *realms* maintains that the function of theories is systematic description and explanation and that to be adequate, all aspects of a theory's descriptions must be correct. Reductionism further requires that nonobservable content be reduced to the observable or some other empirical basis. Instrumentalism construes the function of theories to be prediction of directly observable phenomena and requires only adequate description of directly observable aspects (Suppe in Encyclopedia of Philosophy 1996, p. 521). But as Gale (1979) suggests generalization is another main function of theories. It is generally believed that one of the chief function of scientific research is to discover new truth about the physical universe and then to state these truths in the form of generalization. Generalization of this nature are often called "scientific laws" or "laws of nature," (Gale 1979, p. 42).

As for the structure of theories, Suppe states that, theories utilize specialized concepts and are expressed in technical language, and often invoke mathematical structures. Different philosophical analysis (operationalism, syntactic analyses, semantic conceptions, and structuralist approach) give each feature priority (Suppe in

Encyclopedia of Philosophy 1996, pp. 521–3). According to Suppe a theory contains at least two distinct components: (1) ideals of natural order; and (2) other laws which are used to account for phenomenal deviations from the ideals. Theories are not true or false; rather they are ways of representing phenomenon (Suppe, p. 131). How can we know if a theory is fruitful? Suppe maintains that if the discovered scope of the theory is such that the theory can explain a large variety of phenomena and answer a substantial portion of the questions about the phenomena which are counted as important, then the theory is fruitful—for the meantime (Suppe, pp. 131–2).

Further investigations, changes in presumption, changes in intellectual climate, and so on may cause the fruitfulness of a theory to diminish in that further restrictions in scope are discovered or new questions are held important which the theory cannot answer (Suppe, p. 132).

Theories provide methods for **representing** phenomena.

Possession of a common disciplinary matrix is the mark of a scientific community. Without this the crisis occurs: The breakdown of the scientific community through the loss of a shared disciplinary matrix. Exemplars + disciplinary matrix = paradigm.

The meaning of a word is context-dependent (Hanson in Suppe, p. 161).

Every scientific theory is a system of sentences which are accepted as true ad which may be called *laws* or *asserted statements*. In mathematics these statements follow one another in a definite order, and in accordance with certain principles... In view of these principles, the statements are generally accompanied by arguments whose purpose is to demonstrate their truth. Arguments of this kind are referred to as *proofs,* and the statements established by them are called *theorems* (Tarski 1994, p. 3). The principles...serve the purpose of assuring ...the highest possible degree of *clarity* and *certainty*. From this point of view a method or procedure might be considered ideal if it allowed us to explain the meaning of every expression occurring in this science and to justify each of its

assertions (Tarski 1994, p. 109). The method of constructing a discipline in strict accordance with the foregoing principles is known as *deductive methods*, and the disciplines constructed in this manner are called *deductive theories* (Tarski 1994, p. 111). Deductive method is justifiably the ideal among all methods which are employed in the construction of sciences. ...the application of this method will give the desired results only if all definitions and all proofs fulfill their tasks completely, that is, if the definitions make clear, beyond doubt, the meaning of all the terms to be defined, and if the proofs convince us fully of the validity of all the theorems which were to be proved (Tarski 1994, p. 123).

Examination of the various uses of the term "*theory*" in science indicates that it means various things in various contexts–including scientific field. But one very central use of "theory" involves an epistemic device which is used to characterize the state-change behavior of isolated systems within a general class of phenomena (Suppe 1977, p. 658). Suppe (1977) regards *theory* as **linguistic formulation** (p. 221).

Scientific theories have as their subject matter a class of phenomena known as the intended *scope* of the theory. The task of a theory is to present a generalized description of the phenomena within that intended scope which will enable one to answer a variety of questions about the phenomena and their underlying mechanisms; these questions typically include requests for **predictions, explanations, and descriptions** of the phenomena (Suppe 1977, p. 223). Stroud (2000) in giving a definition for knowledge states that if knowing something could be defined solely in terms of knowledge or experience in some unproblematic, *prior domain*, then that definition should be fulfilled even if you didn't know that knew anything in that domain (Stroud 2000, p. 110).

But even in science there are doubts as to the level of generalization. Generalization in biology, for example, is said to not have features traditionally required of scientific laws: they are never exception less. Biological theorizing has restored to the development of models with local applicability. Biological theory is a sequence of

models that vary in the domains of phenomena to which they apply.

In physics, Einstein created two theories of Relativity, known as the special and the general theory. Each involved new conceptions of space and time. Special theory was based on two principles: principle of relativity and the principle of constancy of the speed of light. Relativity principle was derived from both experiments and symmetry considerations. Einstein's general theory of relativity was to incorporate a generalization of his earlier principle of relativity to cover all states of motion, accelerated as well as uniform.

Is the definition of theory much different in non-scientific fields? In sociological context, for example, a theory is defined as a set of prepositions or theoretical statements. It may be a path diagram, an axiomatic theory, or even a single hypothesis (Hage 1972, p. 172). Hage further adds that these statements or concepts have to be in the form of …a set of interrelated concepts. Hage (1972, p. 173) suggests that a theory needs six parts or components, each of which makes a unique contribution to the whole theory:

Theory	Contribution
1. Concept names	Description and classification
2. Verbal statements	Analysis
3. Theoretical definitions	Meaning
4. Operational definitions	Measurement
	Theoretical linkages plausibility
	Operational linkages testability
5. Ordering into primitive and derived terms	Elimination of tautology
6. Ordering into premises and equations	Elimination of inconsistency

(*Source* Hage 1972)

It is interesting to note that even philosophers do not take the notion of theory quite serious. Hamlyn, for example, states that, cynics have sometimes said that when the term "theory" is used in philosophy it should be treated as a danger signal, a sign that something pretentious but not very informative is going to be presented to us (Hamlyn 1970, p. 3). This might be true in areas which their knowledge base is not clear enough and therefore it involves confusion. In philosophy these kind of knowledge are called *weak knowledge* (see: Malcom in: Pojman 1994, p. 67).

A shift from the universal criteria of positivism may be seen in social sciences. There are three main ideologies that have been invoked by social scientists in the scientific legitimation of their enterprise: social science as an explanatory enterprise of culturally universal validity, an enterprise that is interpretively neutral, and an enterprise that enjoys evaluative interdependence. Post modernists reject all three on the ground of objectivity. But the meta ideologists of social science have claimed many reasons to question the possibility of any universalist, or at least any straightforwardly universalist, theory. Hermeneutic philosophy, which has long been dominant in Germany, and the analytical tradition sponsored by the work of the later Wittgenstein both suggest that any explanation of human behavior has to start with the culturally specific concepts in which people understand their environment and cannot aspire, therefore, to a substantive universality (McCarthy 1978, p. 437).

Habermas introduced into critical theory a fundamental shift in paradigms from the philosophy of the subject to the theory of communication and from means-ends rationally to communicative rationally. Communicative action is the central concept in Habermas's attempt to displace the subject centered approaches to reason characteristic of modern western philosophy with an approach based in a theory of communication.

Indeed, even today, a great deal of the information we need for the normal conduct of our lives is not the product of systematic scientific inquiry but is usually designated as "common-sense" knowledge (Morgenbesser 1967, p. 5) (Figs. 3.1 and 3.2).

Theories in sociology can be started in many ways. The simplest way to begin is to search for some theoretical concepts to describe the social phenomena that interests us (Hage, p. 9). There

Fig. 3.1 Using general
variables to find general
non variables: the case of
conflicts (Hage 1972, p. 29)

Fig. 3.2 The relationship
between sociological
knowledge and
sociological theory (Hage
1972, p. 183)

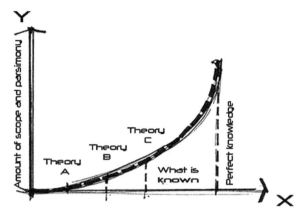

are several reasons why we are concentrating our search for theoretical concepts on general variables:

General variables, by being applicable to all cultures and historical epochs, allow us the possibility of finding a universal law.

General variables also make classification more subtle.

Although it is harder to demonstrate, general variables make thinking much easier.

Theoretical concepts are the foundation of any theory. The first task in constructing a theory, is to find concepts to use in our theoretical statements. The most helpful kind of theoretical concept is the general variable, a continuum that applies to any culture and that any point of time (Ibid, p. 32).

Sociological theories are models of social reality. Knowledge is a set of true laws that describe this picture. Thus theories apply knowledge but they are

never quite there: pieces, isolated theoretical concepts, isolated pairs of pieces, and finally larger combinations: Theories (Ibid, p. 181). Theories, it is said, are best seen as approximation to knowledge (p. 183). Theories are models of reality, not reality itself. Knowledge is a limit towards which theories move.

The role and function of theory in arts, however, are essentially different. In Schopenhauer's theory, our modes of knowledge and understanding, as well as the activities in which we normally engage, are regarded as being determined by the will (The Encyclopedia of Philosophy, vol. 7, p. 329).

Traditionally, the definition of "art" has been the focal point of theorizing about art and has functioned as a kind of summary of a theory of art. Ideally, such a definition is supposed to specify the necessary and sufficient conditions for being a work of art. This leads us to the

Urban Design Language

4.1 Language Definition and Requirements

A universal definition of language is suggested by Charles Morris. Morris' definition is broad enough to fit all the non-linguistic applications of the term. Morris has suggested five criteria for a language: First, a language is <u>composed of a plurality of signs</u>. Second, in a language each sign has a <u>signification common to a number of interpreters</u>. Third, the signs constituting a language must be <u>comsigns</u>, that is, producible by the members of the interpreter-family and have the same signification to the producers which they have to other interpreters. Fourth, the signs, which constitute a language are <u>plurisituational signs</u>, that is, signs with a relative constancy of signification in every situation in which a sign of the sign family in question appears. Fifth, the signs in a language must constitute a system of <u>interconnected sings combinable in some way and not others</u> to form a variety of complex sign-processes. Using these requirements, Morris achieves the proposed definition of language. A language is a set of plurisituational sings with interpersonal significance common to members of an interpreter-family. Particular combinations of the signs that are produced can result in compound signs. Or more simply, Morris defines language as a set of plurisituational comsigns restricted in the ways in which they may be combined (Morris 1946).

From Morris' definition of language, we may conclude that there are two basic elements necessary to constitute a language: A vocabulary (lexicon) and a grammar (syntax). Each of these elements, in turn, should cover certain requirements such as the ones suggested by Morris for signs.

It is quite logical to expect that a language has the same characteristics of the knowledge that it is representing and vice versa. This is part of the intrinsic nature of a language. If we could identify the two minimum elements of *vocabulary* and *grammar* in an area of knowledge, we could easily form the language of that particular area of knowledge. It is on this basis that Langer has argued that the arts, for example, do not have a language. The reason, as Langer suggests, is that the arts have no vocabulary, that is, no body of signs with an assignable signification, no words and symbols with fixed meanings. Langer argues that since there are no words or symbols, there can be no dictionary of fixed meanings for line, shading, colors, and the other elements of artistic technique. Therefore, there cannot be a dictionary to translate, bit-for-bit, one area of the arts into another. Rather, the meaning for all of the artistic elements is completely subject to context; there are no fixed meanings apart from and independent of context (Langer 1942).

The reason that forming a language for some of the areas of knowledge, such as arts, is problematic, is that these areas do not have a

© Springer International Publishing Switzerland 2016
H. Bahrainy and A. Bakhtiar, *Toward an Integrative Theory of Urban Design*,
University of Tehran Science and Humanities Series, DOI 10.1007/978-3-319-32665-8_4

series of laws that govern the practice and application of the methods and techniques of those areas of knowledge. Any product or creation in an area of knowledge with an established language, must be a composite of symbols with resultant new meanings. Therefore, language must have permanent units of meaning which are combinable into larger units, must have fixed equivalences that make definition and translation possible, and finally, must have connotations that are general. Architecture, on the other hand, can have a language since there can be known units of meaning—*architectural words* (such as doors, windows, columns, etc.), and *architectural syntax,* or the rules for combining the various words in order to produce larger meanings (Jencks 1977, p. 52).[1]

According to Morris' definition of language, a series of qualified signs, as was discussed earlier, is the basic requirement for a language. The qualified signs of a language not only comprise the essential units by which larger forms of that language may be built, but they also suggest the kinds of laws and rules that are required to build those larger forms. But still more important, the qualified signs of a language determine and specify the family or group that an interpreter-family can use to interpret the signs of the language. Signs are capable of identifying the qualified members of the interpreter-family and hence of pinpointing those that do not belong to the interpreter family. According to this explanation, it would seem that the degree of commonality and plurality of the signs will dictate the degree of commonality of the language they represent. The more specialized the signs, the smaller and more restricted the interpreter-family will be. The size of such a family may range from a minimum of one member, (as in the case of a person who invents his own arbitrary language known only to himself), to a maximum of a family that could include all of humanity (as in the case of the language of nature). When this is the case, is there any minimum acceptable size for the interpreter-family to justify the legitimacy

of the language used? In other words, how private can a language be and still be called a language? What factors should be considered in delineating the size of an interpreter family? Is the size of such a group controllable by the members of the family or by somebody or something else? Can anyone learn the language and become a part of the family?

Since a language represents an area of knowledge, it will contain all the characteristics and attributes of the knowledge it represents. Questions concerning the size of the interpreter-family (all those who can understand the language), its degree of plurality, and so on, all depend on the nature and characteristics of the particular knowledge area involved. What is important here is the formation of the two minimum requirements of the language on the basis of a careful realization of their requirements.

On the basis of what was discussed above, the following guidelines may be used in formulating the language of urban design:

Language is used here in its broad sense which goes far beyond the definition of language as a linguistic tool.

Language is regarded as the medium and the key to knowledge.

Language as an instrument can be used to express thoughts, communicate ideas and develop new areas of knowledge.

The general definition of language given by Morris will be adopted for the purpose of this study. This definition is: Language is a set of plurisituational comsigns restricted in the ways in which they may be combined.

A language requires at least two basic elements: A vocabulary (sings) and a grammar (syntax).

The signs of a language should satisfy five requirements which are also the requirements for a language: A plurality of signs, a commonality of signification, comsigns, plurisituational signs and interconnected signs which are combinable in some ways but not in others.

Language has the same characteristics as the knowledge that it represents, and vice versa (Figs. 4.1 and 4.2).

[1]The units in architecture, for example, may be identified as architectural space and architectural activities.

Fig. 4.1 Transmission of information from point A to point B

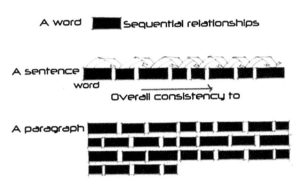

Fig. 4.2 The three-level hierarchy of word, sentence, paragraph and text

4.2 Language as a Tool for Knowledge Representational

Language, by means of symbols, presents images and ideas to the mind—by sounds in speech, by visual signs in written language. By smile or analogy or association there is the additional symbolism of an idea or image standing for or suggesting another, and this often a powerful means of expression (Whittick 1960, p. 368). Edward Hill (1966, p. 8) states that language functions as a means of collecting, ordering, relating, and retaining experience. We house our memory-thoughts in words and faint images; and the maze of sensations and perceptions that enter in upon our mind are given a form through language, the first instrument of order. According to Hill language is both incentive and means to pursue and understanding of experience.

Civilization, the process of man's development beyond mere animal existence, has been achieved largely by his ability to use and invent symbols. Communication depends on the symbolism of language, and thus man becomes aware of another's thought by means of symbols. By language combined with his propensity to dream, plan and speculate, which is in part a further type of symbolism, man extends his thought beyond his own time and place, a detachment indispensable to the enlargement of his activities. 'By this act of detachment and abstraction,' says Lewis Mumford, 'man gained the power of dealing with the non-present, the unseen, the remote, and the internal: not merely his visible lair and his daily companions, but his ancestors and his descendants and the sun and the moon and the stars: eventually the concepts of eternity and infinity, of electron and universe: he reduced a thousand potential occasions in all their variety and flux to a single symbol that indicated what was common to them all' (Mumford 1950). Carlyle (1939) believes in the dependence of civilization on symbolism. He suggests that it is in and through symbols that man, consciously or unconsciously, lives, works, and has his being.

Knight (1981) maintains that any design can be understood, in a syntactic or compositional sense, as a complex of shapes and relationships between these shapes. In formal terms, this kind of understanding corresponds to viewing a design in terms of a *vocabulary* of *shapes* occurring in the design and a set of *spatial relations* between these shapes. Here, a *shape* is defined as a finite collection of lines, a *vocabulary* as a set of shapes no two of which are similar, and a *spatial relation* as a collection or

arrangement of shapes. Knight further concludes that a set of shape rules and an initial shape determine a *shape grammar*. A shape grammar generates a *language of designs*. The designs in a language are syntactically alike in that their compositions are governed by the same spatial relations (knight 1981, pp. 213–14). Later Knight claimed that a language could be transformed into a new one by altering basic elements (shapes and spatial relations between them) of the compositional structure of designs in the language (Knight 1983, pp. 125–28).

One of the fundamental concepts of modern architectural theory is the idea that architecture is a form of language (Lavin 1992). According to Lavin Quatremere de Quincy used language to provide architecture with a conventional rather than natural model, a conceptual transformation that led him to equate architecture's capacity for progressive development with its sociality (see also: Collins 1965; Saisselin 1975; Guillerme 1977; Stafford (1979). Lavin suggests that to regard architecture as language means, above all, to see architecture as woven into the fabric of society. According to Lavin (1992), Quatremere has repeatedly stated that architecture is language. In his view all architectures are languages and individual languages only have value relative to their particular contexts (Lavin 1992, p. 185). Lavin does not specify the structure and form of the language of architecture. But concludes that if we accept that architecture is language this has the effect of assigning to society the task nature has traditionally fulfilled as the progenitor of architectural meaning (Lavin 1992, p. 176). According to Quatremere, language and architecture each had innate operating systems such that "columns, cross beams, capitals, and other things that are the natural elements of the art of building are, consequently, and to all architectures throughout the world, the same as the elements of universal grammar are to diverse languages (Lavin 1992, p. 97).

Architects use forms and materials as symbols. Composition is as characteristic of a style as its details; it unites the details in a system which may, with a stretch of the imagination, be compared to a language. The "words" of such a language are the elementary and characteristic forms, such as columns, pilasters, entablatures and moldings; composition is its "grammar". Both the details and the composition carry a meaning. Different styles are different languages, often as hard to understand for a modern spectator as a foreign language (Park 1968). Park finds three concepts in architecture: place, space, and structure. Then he suggests: proportion, size, angularity, regularity, and plasticity as the main attributes of form. Structure has two main characteristics: Homogeneity and continuity. Spatial compositions consist of position (location and connection) and similarity (Park 1968). Park, however, does not put these elements together in order to construct a language, which has its vocabulary and grammar.

The semilogist Umberto Eco (Guillerme 1977) has seen "architectural language" as an "authentic linguistic system obeying the same rules that govern the articulation of natural languages". Following Eco, A. Silipo has applied a conventional definition of grammar to architecture, in his words: "considering architecture activity to be a set of operations designed to establish cognitive relationships by means of spatial realities, and (considering) the architectonic organism as a structure, an instrument of communication and of knowledge, *grammatical* analysis becomes the principal critical instrument at the disposal of whoever seeks not only to grasp the entire range of signification of a particular spatial structure, but also to "historicize" it by going back to the methodological matrices that have been determined this structure, and by grasping the relationships that exist among the figurative, technological and functional elements that make up the structure and the more general historical, social and economic, and artistic context to which it refers" (Guillerme 1977, p. 21).

Spirn (1998, p. 4) believes that language of landscape is the principal language in which I think and act; my conviction that there is such a language arises first from that fact. It is also the language used skillfully by designers. To Spirn, language of landscape is our native language. Landscape was the original dwelling; human evolved among plants and animals, under the sky, upon the earth, near water. Everyone carries

that legacy in body and mind. Humans touched, saw, heard, smelled, tasted, lived in, and shaped landscapes before the species had words to describe what it did. Landscapes were the first human texts, read before the invention of other signs and symbols (Spirn 1998, p. 15). Landscape, as language, makes thought tangible and imagination possible. Through it humans share experience with future generations, just as ancestors inscribed their values and beliefs in the landscapes they left as legacy. Spirn believes that landscape has all the features of language. It contains the equivalent of words and parts of speech—patterns of shape, structure, material, formation and function. All landscapes are combinations of these. Like the meanings of words, the meanings of landscape elements (water, for example) are only potential until context shapes them. Rules of grammar govern and guide how landscapes are formed, some specific to places and their local dialects, others universal (Spirn 1998, p. 15).

Nelson Goodman's trailblazing *language of art* reorients aesthetics. Active engagement, not passive contemplation, marks the AESTHETIC ATTITUDE. Understanding rather than appreciation is its goal. Works of art are symbols that require interpretation. *Languages of art* provides a taxonomy of syntactic and semantic systems deployed in the arts and elsewhere, detailing their strengths and limitations (Goodman 1976).

'Symbol' is really a generic term, and in the modern sense includes all that is meant by a sign, mark or token. It is generally regarded, in various spheres of thought—sociology, art, philosophy—as that which stands for something else. The Greek word from which the term symbol is derived appears to have meant a bringing together, and this meaning is the logical antecedent of the modern meaning, for symbolism is a bringing together of ideas and objects, one of which expresses the other. The symbol is either an object that stands for another object, or an object that stands for an idea. Muller (1965) contended that without language, or signs that correspond to language, thought is impossible.

Symbols are conventionally divided into four classes: (1) Symbolism of a concrete object or group of objects by approximate or conventional imitation, and of a part of an object to represent the whole; (2) Symbolism of an idea, activity, occupation, or custom by an object associated with it; (3) symbolism of an idea by an object which by its nature, analogous character, function or purpose suggests the idea; (4) symbolism of an idea by the relationship of two or more objects; and (5) symbolism of an idea or concrete object by shapes incorporated in the design which suggest or express the idea or object. This last one is exceedingly important in artistic expression, therefore, we now turn into the discussion of symbols in architecture.

Adherents to the different positions may argue that linguistic theories provide the most precise way of characterizing particular languages. A theory, or a grammar, supplies a set of rules describing the semantic properties of the basic expressions and their permissible syntactic combinations into meaningful wholes (Encyc. p. 287).

As to the interpretation of linguistic theories and the nature of the linguistic objects and properties they describe, mentalist's (such as Chomsky) ideas seem to be more relevant to the purpose of this study. Mentalists see linguistics as a branch of cognitive psychology and take linguistic theories to be about the psychological states of processes of linguistically competent speakers. Chomsky insists that the best account of speaker's actual languages should fit the facts about the meanings and structures individuals actually give to expressions: Theories of language should be tailored to the contours of linguistic competence. Thus for Chomsky, a theory of language is a theory of a speaker's knowledge of language. For mentalists, language is not in the world. The world contains only marks and sounds. Language is in the mind of speakers and consists in the assignments of meaning and structure given to particular marks and sounds. **For Chomsky, a grammar is a theory** of the speaker's linguistic competence: an internalized system of rules or principles a person uses to map sounds to meanings. This is a body of tacit knowledge that the speaker puts to se in the production and comprehension of speech. It

contains a largely innate, and species-specific, component common to all human language users. The workings of this component are described by universal grammar (Chomsky 1986).

But is language static, stable, and fixed? Keller (1994) suggests that language change follows Adam Smith's proposal of the invisible hand—an evolutionary theory of the development of language based on a cultural model, such as that of the invisible hand. The justification for calling a process of historical change an evolutionary process derives from the fulfillment of three conditions. The first is that the process should not be a teleological one: in language change there is no definite preset goal that has to be achieved. The second is that it should be accumulative process of small changes: it is brought about by entire populations and not by individuals. The third is that the dynamics of the process must be based on the interplay between variation and selection: a natural language is an instrument for exerting influence upon others. Linguistic competence is the cluster of hypothesis from which we choose the form most adequate to the circumstances, and only those forms that partially or totally fail will lead to modifications.

In this regard, Stein and Harper (2012) believe in the 'fluid nature of language' and claim that this fluidity will foster creativity and innovation. According to them if planner/designer views language as fluid, dynamic and flexible, his/her interpretation of planning/design language will be more adaptable to changing environments.

Considering that language is a human artifact, the linguistic acts of human beings can bring about the evolution of natural phenomena and of artifacts. Language is then a "custom of influence" which emerges "invisibly handed", without a plan or the intention to create it, through the natural behavior pattern of humans.

Given the absolute centrality of language for all forms of social life, it is hard to imagine that a theory of action that excludes communication could have more than limited applicability. A general theory of rational action must give some account of all rational activities (Heath 2001, p. 3). In Habermas' view, the ultimate

source of validity is language. Certain key practices associated with language use have a special sort of normative authority, because language is *a vehicle of thought* (Ibid, p. 27).

4.3 Language, Thought and Knowledge

One of the most important developments in the contemporary social and human sciences is "the turn to language." Since Aristotelian times, poets, and philosophers, physicists, and psychologist—most of human kind, in fact—have recognized that there is a relationship between language and thought. Aristotle's view, widely adopted in the centuries since, was that language was a medium thorough which to communicate thought. The science of language itself—modern Western linguistics—ironically, has seemed slow in responding to this language project but has remained largely preoccupied with its perennial search for general notions and rules of the sentence or the text. Shi-Xu (2000) has taken up the discourse of linguistic theorizing as the focus of attention, especially the ways in which basic assumptions about language are formulated and discussed. One of the significant findings of this study is that the very object of linguistic investigation is a social discursive construction and that therefore there is profound kinship of the language of inquiry with inquiry itself.

Coseriu (1981) claims that language is essentially a cognitive faculty and cognitive activity, realized by the creation of symbolic signs. As language is ontologically knowledge, it cannot reify its object; the linguistic sign therefore does not have a unitary ontological status. It is argued that the cognitive status of language is habitual, not operational or objective—intentional, and that a unified theory of language depends on the identification of the habits to which each verbal expression strictly corresponds(Garcia Turza and Claudio Sobre 1999, pp. 33–68) (Fig. 4.3).

Language as part of the mind is essentially Chomsky's idea. He claims that we know the grammatical principles of our language in pretty

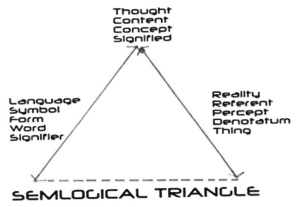

Fig. 4.3 The relationship between reality, thought and language (after Morris 1955)

much the same sense that we know ordinary things about the world (e.g. facts), a view about linguistic knowledge that is called "*cognitivism.*" (Knowels 2000, pp. 325–353). Chomskyan theory has always emphasized language as a property of the mind rather than a social behavior. The first goal of linguists is to establish what an individual human mind knows—*linguistic competence.* Hence the term "Grammar" is more fundamental than the term "language"; language is an artificial generalization to do with society, and epiphenomenon; what the individual mind know is a grammar.

Language knowledge takes the form of universal principles common to all languages and parameters with values specific to a particular language. These elements have quite different properties from other cognitive systems and do not develop out of them. Hence language is claimed to be a separate mental faculty of its own, quite distinct from other faculties of the mind. The language faculty is held to be the unique generic endowment of the human species.

Universal Grammar (UG), the part of the mind common to all human beings that enables them to know and acquire languages. The important things are the general properties that languages have in common rather than the idiosyncratic ways in which they differ. Languages are basically very similar, differing largely in the actual lexical items and their behavior (Encyc. 1998, pp. 37–38). Therefore, as Stohr (1996) has stated, not only do we make use of

language to fix our thoughts and to communicate our knowledge; we also think in our language, so that the structure of our thought reflects the logical forms of our language.

Davidson (1975) argues that there can not be thought without language: in order to have thoughts, a creature must be a member of a language communities.

What is the nature of linguistic meaning? There are two dominant views on this, one regards linguistic meaning as conventional, and other compositional. Conventional in the sense that instead of the notion of an explicitly formulated rule we can make use of the notion of a convention, defined as a rationally self-perpetuating regularity (Lewis 1969). The compositional position believes that the meanings of sentences depend on the meanings of words and phrases (semantic theory) (Davis 1991). Are these two views mutually exclusive or they can be fused into one?

George Gale (1979) insists on the need for a precise language. He states that every field of study has its own special language, with it own special words, meanings, and concepts. The reason for this is not too difficult to find: Each discipline looks very closely and precisely at a restricted part of the universe. This sort of close inspection and precision requires a clarity of linguistic function far beyond that found in everyday language. Thus we are forced into technical, manufactured languages for each discipline. The theory of science, therefore, has

developed its own technical language. The fundamental elements of this technical language have been borrowed from modern formal logic (Gale 1979, p. 25).

Carruthers (1996) considers whether natural language is merely a tool for communication between individuals or whether it is also, within the individual, a medium for thought. Carruthers adopts a version of the latter hypothesis: he argues that human thinking consists in sequences of natural language sentences: and that sentences do not merely encode thought, they constitute them.

4.4 Urban Design Language

It is becoming more and more common in a vast variety of fields and disciplines, to use the term *language* to imply different meanings and to serve a wide range of purposes (Kepes 1944; Cooke 1957; Hoskin 1968; Abrams 1971; Alexander 1977; Jencks 1977; Zevi 1978; Bahrainy 1981, 1995; Lavin 1992; Ishizaka; Yanagida 1995; Van Zanten 1996). It seems clear from such diverse applications of the term *language,* that the term now has moved far from its original meaning as a speech tool; language now has come to mean also an effective analogical tool of communication, expression and representation. It is the broader sense and meaning of the term *language* that has attracted the attention of experts in many fields. According to Jencks (1977, p. 39) for example, there are various analogies architecture shares with language. If we use terms loosely, we can speak of architectural *'words'*, *'phrases'*, *'syntax'* and *'semantics'*. Eisenman (1986) has also seen architecture as *"a second language"*, the first which is ordinary speech and writing. Norberg-Schulz (1963) suggest that we can liken city to a language and seek insights from the discipline of linguistics, either in terms of syntactic structure or else, through the study of the meaning of signs, in semiotics. Gosling (2003) suggests that linguistic theory has major application in urban design. He refers to American writer Safire's (1990) suggestion that the ideas of icon (used extensively in architectural language) have

their roots in "semiotics, the theory of the relationships of signs in language" (Gosling 2003, pp. 218–19). One of the fundamental concepts of modern architectural theory, Lavin maintains, is the idea that architecture is a form of language (Lavin 1992). Lavin believes that Quatremere de Quinsy used language to provide architecture with a conventional rather than natural model, a conceptual transformation that led him to equate architecture's capacity for progressive development with its sociality (see also: Collins 1965; Saisselin 1975; Guillerme 1977; Stafford 1979).

What is the relationship of an area of knowledge and its language? Language, it is said, is the medium and key to knowledge. Knowledge of any nature is formulated and conveyed in a language—i.e., in a medium of signs and symbols. Without the language of a particular field, one can neither possess the knowledge of that field nor effectively communicate with the members of the knowledge community.

Language functions like an instrument. To form a language means to invent an instrument for a particular purpose on the basis of certain laws and requirements. The purpose of this instrument is to express thought, to communicate ideas and to develop and add new knowledge to the already existing body of knowledge. To understand a language, therefore, means to be the master of the techniques or to use the instrument properly.

Any knowledge is, by nature, unstructured, diversified and sporadic. This is, of course, much more true in the case of the knowledge of urban design which is still young, undeveloped and unformed when compared to the knowledge of more established disciplines. Development in each area of urban design is taking place independently of developments in other areas of the field. This situation makes it impossible for the practicing urban designer to possess and apply the unstructured knowledge of urban design. Developing a language, therefore, will be of critical help. This language will be a tool or instrument which will represent the knowledge of urban design, facilitate communication in the field and provide guidelines for the practice of urban design.

Alexander (1998) suggests that if we consider a contingent framework, a general theory of planning is not impossible. He further suggests that while no single planning paradigm can be complete general theory of planning, a contingent framework can offer a useful basis for thinking about planning—a kind of 'public order' in the planning theory community.

Alexander (2000) has presented an integrative theory of urban design, which he believes is in its incipient and preliminary form. The suggested principles which are solely substantive include: form, legibility, vitality, and meaning.

Moudon (1992) has made the first attempt at building an epistemology for urban design, by introducing an organizing framework, through a review of the urban design literature from 1920s to 1980s, titled: 'A catholic approach to organizing what urban designers should know'. She proposes nine areas of concentration to encompass research useful to urban design. They include: urban history studies, picturesque studies, image studies, environment-behavior studies, place studies, material culture studies, typology-morphology studies, space-morphology studies, and nature-ecology studies.

Characteristics of contemporary urban design practice and its context include trends towards practice at an increasing range of territorial scales (from the neighborhood to the regional) in an increasing variety of cultures and geographies. The context for that work is characterized by increasingly complex relationships between global phenomena (tourism, sub-urbanization, commercialization and post-industrialization) and local conditions: increasing degradation of landscapes and urban areas (recognizing the increasing importance of functioning natural systems within the urban matrix): and increasingly complex and rapid decision making, delivery and urban management processes. Urban design teams operating in culturally sensitive environments need, as a result, to develop working capacities that detect and respond to such issues. For these circumstances urban designers should learn to be:

Reflective in their practice

Accepting of an able to work respectfully with 'difference' and 'the other'

Cultural, and cross-cultural, practitioners as well as technical experts

Effective communicators able to develop 'greater dialogues' across diverse group

Able to access, analyze and learn from an emerging and increasingly diverse range of international experiences in urban design

Able to understand and model the many processes that manifest the physical and social phenomena in both global and local cultures

Knowledgeable about the range of methodological models available to effect change, and

Able to imagine script and choreograph complex processes of interaction to effect physical and social change.

Integrative Language of Urban Design

<div style="text-align:right">**5**</div>

5.1 Formulating the Integrative Language of Urban Design

The general guidelines outlined above will be used in the formulation of the language of urban design. Among these, the requirements and qualifications mentioned in points five and six are critically important. Still more important are the signs and their qualifications, since they represent the substance of the knowledge base of urban design. The knowledge base of urban design, as suggested above, is an integrated, complex knowledge consisting of intuitive-scientific procedural elements and formal-functional substantive elements. The language of urban design as a method of communication and a symbolic and representation tool, should represent all the individual components of the knowledge base of urban design, its attributes and points of focus as well as the overall complexity, unity and interrelationship of the various aspects of the knowledge base. In order to qualify as a language, these factors must be reflected in the two basic elements of the language devised.

We now proceed to construct the language of urban design by exploring the equivalent of the two language elements and by testing them against the five criteria adopted earlier. The two basic requirements are: A vocabulary, or a set of signs, and a grammar, or a set of rules.

To fill the significant roles of representation and communication efficiently and properly, the signs of the language must be common signs, i.e., their meanings and interpretations must be shared by all the parties involved. To achieve this goal, the language of urban design must include both the language of the physical environment– formal and functional– as well as the procedural language which deals with the process of design itself. The formal language of the environment deals with space, form, perception and vision; the functional language is concerned with the content of urban form, i.e., with the activities that take place in the urban environment.

From the four areas of the knowledge base of urban design, substantive elements are equivalent to the vocabulary or signs and procedural elements are equivalent to the grammar or rules of the language. Vocabulary, therefore, will represent element of (1) urban form and space, and element, and (2) urban activities. Rules, on the other hand, will represent the integrative, intuitive and scientific principles applied in urban design (see Fig. 5.1).

Signs, which represent the substantive elements of knowledge are to be the smallest complete and meaningful units (such as words in a speech language), which can be combined with other units, according to certain rules, to form larger structures (such as sentences). As mentioned above, it is absolutely essential for these signs to thoroughly represent the substantive elements of urban design. To do this, they have to be defined exclusively and inclusively in order to be differentiated from similar signs which

© Springer International Publishing Switzerland 2016
H. Bahrainy and A. Bakhtiar, *Toward an Integrative Theory of Urban Design*,
University of Tehran Science and Humanities Series, DOI 10.1007/978-3-319-32665-8_5

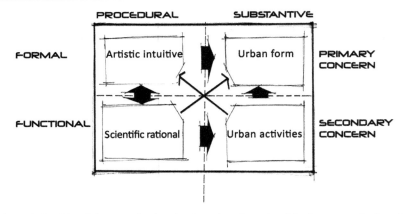

Fig. 5.1 The interrelationship of the procedural and substantive elements of the language of urban design

represent other areas such as architectural and regional spaces and activities, which, although they maintain a reciprocal and hierarchical relationship with urban space and activities, contain different level of complexity and size which represent different areas of environmental design (see Fig. 5.2).

The smallest complete unit of urban form is *urban space*. Urban space has been under broad investigation by many researchers and writers, due to its determining role in urban design (see for example: Ross King, G. Broadbent, Christoph Lindner; Stephan Carr, Mark Francis, Leanne G. Rivlin and Andrew M. Stone; Rob Krier, Matthew Carmona, Geoffrey Broadbent, John Morris Dixon, Mike Crang, Tridib Banerjee, etc.

Urban space is defined here as the container of the average daily circuit which is composed of urban activity systems. The aggregate of the daily circuit of urban activity systems, which

represents the smallest complete unit of urban activities in the language of urban design is defined here as the average of a person's daily, weekly or yearly routine of activities in the urban environment. These activities include such things as recreational activities, shopping, driving to work, going to church, walking to school, visiting, etc. Repetitive patterns of such activities are called *urban activity patterns*, examples of which are: shopping patterns, home to work commuting patterns, recreational patterns, and so on (Figs. 5.3 and 5.4).

Urban space and the *circuit of urban activities* which represent urban form and urban activity systems correspondingly, comprise the signs or units, or the vocabulary of the urban design language; these satisfy the first requirement for a language of urban design. It should be pointed out that urban space is static by nature as is each activity in its own particular location. The relationship between the activities, however, is

Fig. 5.2 Hierarchical relationship of the substantive elements in three areas of environmental design

Fig. 5.3 Examples of urban spaces **a–c**: different urban destinations

Fig. 5.4 Urban activity pattern

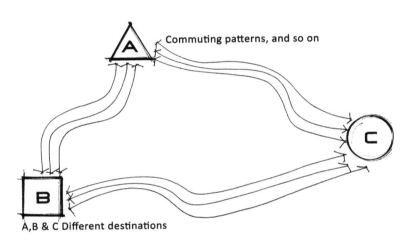

dynamic and creates movement in the urban environment. This occurs because of the spatial distribution of activities in the environment which may be represented by the distance between the activities or its proxy in time. This factor is the basis of the circuit of activities.

As mentioned earlier, the two units—urban space and activity circuit—have to meet certain requirements in order to qualify as the signs of the language. To this end, they will be tested here against the five criteria adopted earlier. This test has, of course, only a general validity because it does not consider the cultural differences in the meaning and interpretation of these signs. The resultant language of urban design will obviously require a great deal of modification of the signs.

First, the plurality of signs criteria is met here because each set of signs may be repeated numerous times. An activity circuit is the unit of urban activity systems; it is what people do in the urban environment. The repetition of an activity circuit leads to an urban activity pattern. The unit of urban space is also repeatable and its repetition leads to a larger physical environment.

Second, the significations of the signs are shared by the users and participants. Since the units represent the activities people engage in and the space in which these activities take place, their significations are shared by the participants.

Third, the signs are producible by the participants and users, and when produced will convey a common meaning. Producibility, is in fact, the

result of the two previous elements of plurality and the common signification of signs. In other words, when signs have the characteristics of plurality, they are producible; when they have common significations, the produced signs will convey a common signification.

Fourth, the signs have a relatively constant signification. The units of urban space the activity circuit do not belong to any specific environment. Rather, they are abstract and their significations, therefore, are also universal. The signs simply represent the urban physical environment. Although one may see many similarities between the various daily activities of the inhabitants of different cultures, what is more critical and valuable are the dissimilarities and differences between the units in different places and different times. Some of these differences have been already investigated cross-culturally (examples are the meanings and uses of spaces). The meanings and significations of signs, therefore, are culturally bound and subject to significant changes (Bahrainy 1995).

Finally, signs are combinable on the basis of certain rules. In the case of language of urban design, these are the integrative rules and principles of the discipline. These integrative rules and principles satisfy the second requirement for a language of urban design. The idea behind searching for the units and constructing the language is to eventually control and guide the formation of the larger structures on the basis of certain general rules and principles. In other words, in order to achieve certain desired goals in the physical environment, the process of building the environment has to be based on these rules and principles. These rules govern the relationship between nature and the built-environment, between man and the environment and between man and man himself.

To qualify as the rules of language of urban design, the rules must: thoroughly represent the procedural elements of the knowledge base of urban design, which is the integrative-intuitive and scientific methods applied in urban design (elements 3 and 4), and (2) must have the capacity to construct larger structures out of the units (urban space and activities); these larger

structures must fit the general characteristics and qualifications of the signs or units that were given before. This set of criteria requires that the rules of the language be derived form or based on the contents and characteristics of the substantive elements of urban design, i.e., on urban form and urban activity systems. Efforts, therefore, have been made to explore a set of rules and principles which can best represent the complexity and diversity of the methods and processes applied in urban design.

5.2 Rules and Principles of the Language of Urban Design

Art and science are both necessary, should exist, but both need significant integration if we are to succeed in specific and coordinated urban design knowledge (Cuthbert 2007).

Procedural rules are carefully extracted from a variety of concepts, principles, theories and rules which have been commonly applied in urban design or which have the potential of being commonly applied in the future. Again, the aspect of commonality should be emphasized here because it is essential for the formulation of a common language. As a real representation of the integrated methods and processes of urban design, these rules and principles must also be integrated into a unified set of rules and principles. The integration of these rules, however, should be considered a mental activity which may be realized through intuition. The successful application of the language urban design is heavily dependent on such an intuitive integration of these rules.

There are three points to be explained here with regard to these rules and principles. First, this list is not to be considered a complete and exhaustive one. There may be some principles which have not been included and others that have yet to be developed. Second, the principle are derived from three different sources of knowledge (see Fig. 5.5). (1) From the available relevant meta theories (or philosophy), such as critical theory, sustainability, normative ethical

Fig. 5.5 Three ways of formulating the integrative theory of urban design

Fig. 5.6 Formulating the language (theory) of urban design

theories, etc., and (2) from the field or the practice of urban design. (3) From both 1 and two. Third, the principles should not be seen as independent and complete in and of themselves. They are interrelated and interdependent members of the family of the language of urban design. This language represents the integrated knowledge base of urban design (Figs. 5.6 and 5.7).

Fourth, based on what was suggested before, the activities of urban design may be divided in two levels: global and local. In many cases, however, due to some common characteristics—such as religious, socio-economic, and climatic features—in certain regions, on the one hand, and significant differences due to micro climatic conditions and other factors, on the other, another level may be recognized as regional. The local level is in fact the culture specific ones and best fits the unique characteristics of each settlement or a group of settlements. The following rules and principles are presented in two categories: global and local. For local we used the

cities in the hot and dry region in the central plateau of Iran, which includes the cities of Isfahan, Yazd, Kashan, etc.

5.2.1 Integrative Rules and Principles

5.2.1.1 Patternization

An orderly repetition of a form, event or state is pattern and an orderly repetition of pattern is patternization. This general and broad definition covers many different kinds of patterns which are all of basic significance in the activities of man and hence, in the field of urban design (Figs. 5.8 and 5.9)

Patterns and patternization are essential to the functioning of all the human senses and to the human intellect. They are the basis of human senses and human perception, knowing and understanding: seeing, hearing, and perceiving. It is the mother principle in a way that all other principles are, in one way or another, related to this

Fig. 5.7 Integrative rules
and principles of urban
design language

principle. They have been the subjects of extensive scientific study under the heading of invariance. A special form of invariance is called symmetry. Symmetry is so prevalent that we expect a certain degree of symmetry in everything.

Symmetry signifies rest and binding, while asymmetry signifies motion and loosening. One is order and law, the other arbitrariness and accident. The one is formal rigidity, constraint and principle while the other is life, play and freedom. Symmetry establishes a wonderful cousinship between objects, phenomena and theories, which are outwardly unrelated. Patternization also deals with simplicity, regularity, stability, balance, order, harmony and homogeneity. A classical exemplification of the law of patternization in urban design is perceptual

organization, or the tendency to maximize regularity in our perceptual system.

The urban environment is constituted by patterns, such as patterns of settlements, patterns of ecology, patterns of behavior, patterns of perceptual and visual continuity, the rhythm and pattern of events, sequences of space, views and motions, geometrical forms and patterns such as the central place theory and grid system, the patterns of cities, and so on (Fig. 5.10).

5.2.1.2 Quantization

Quantization is based on the Quantum Theory (Max Plank 1900) and is one aspect of patternzation. It deals with continuity/discontinuity concepts. Its application can be seen in all areas to explain, measure, and control change

Fig. 5.8 The
interrelationship of the
procedural and substantive
elements of the language of
urban design

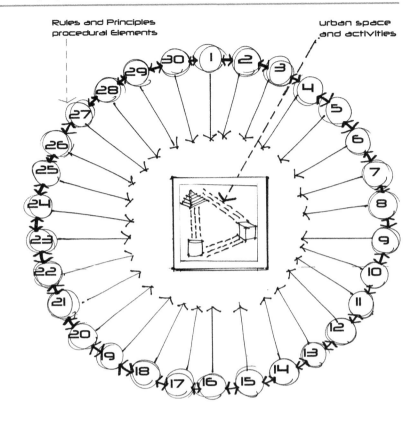

Fig. 5.9 Integrated rules
are applied to the
disordered environment,
manipulating its elements
to establish order

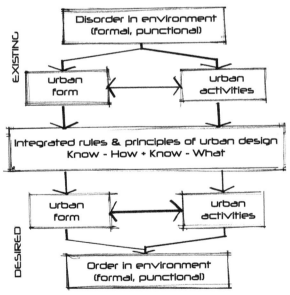

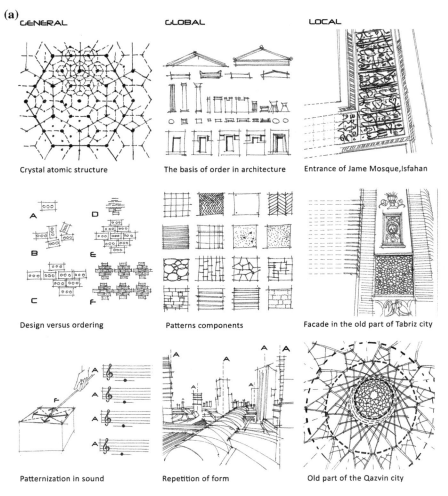

Fig. 5.10 **a** An orderly repetition of a form, event or state is pattern and an orderly repetition of pattern is patternization. **b** Patterns and patternization are essential to the functioning of all the human senses and to the human intellect

(visual quality). Visual characteristics such as: attraction, complexity, richness, legibility, and cohesion; against dullness, simplicity, poorness, boredom, monotony, ambiguity, confusion, chaos, and repetition can be studied analytically through this principle. Desired change and repetition, continuity, balanced, movement, diversity, cohesion. It is based on the concepts of continuity and discontinuity. In the physical environment one can find complementary aspects of continuity and discontinuity in the form of fluctuations in the level of information. In the structures made of these fluctuations (or waves), there are the complementary aspects of repetition and

variation. The bundles of these waves are combined in the total structure to produce organic complexes that are more than the sum of their component parts. The physical environment provides patterns, which follow the quantization rules. These rules will provide new insights into the correlation of ideas and concepts in urban design. Quantization in urban form deals with the visual quality of the built environment and with people's perceptions, preferences and tastes. The quantization principle makes it possible to quantify measure, explain, predict and control the rhythmic changes of the visual quality of the environment. It is the form, size and frequency of

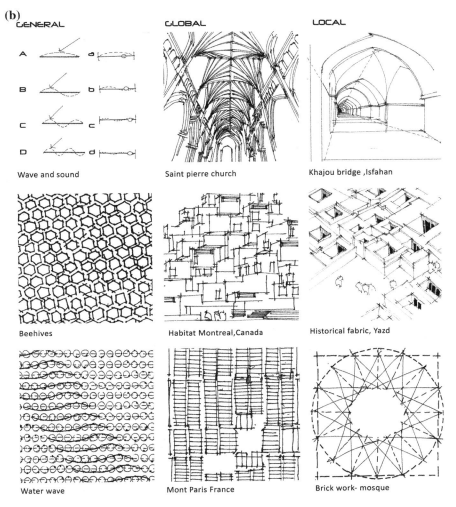

(b)

GENERAL	GLOBAL	LOCAL
Wave and sound	Saint pierre church	Khajou bridge ,Isfahan
Beehives	Habitat Montreal,Canada	Historical fabric, Yazd
Water wave	Mont Paris France	Brick work- mosque

Fig. 5.10 (continued)

these rhythmic changes (waves) that make an environment exciting, complex, rich, legible, identifiable and cohesive or boring, monotonous and confusing (for more information see Appendix) (Fig. 5.11).

5.2.1.3 Centrality

Centrality is a very common form of patternization, which can be applied to almost any subject including that of urban design. Many examples of such an application may be found in environmental design for the urban core, central business district, nodes, commercial centers, inner city, town centers, etc.

Any urban design activity deals with the patterns of centering, subcentering, and non-centering as the form expressions of different actions and reactions to the environment. From the market standpoint, for example, it is always possible to apply the central place theory and to identify the central activity cluster within each physically identifiable urban node. However, more sophisticated approaches must be sought to distinguish each center's place in the hierarchy of centers according to the extent of the territorial market establishments that are located there.

It is a basic psychological need to erect centers. This must be considered in the layout and

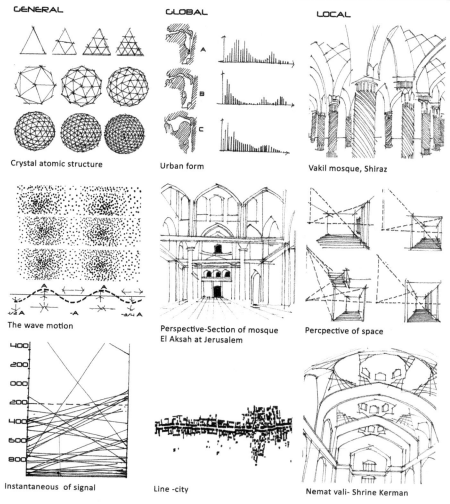

Fig. 5.11 Quantization deals with continuity/discontinuity concepts

formation of activity centers in cities. This need might manifest itself either in real world centers or in the centers of the inner world. One, however, reflects the need for the other.

Centrality in urban design may be said to originate from many sources such as religious impulse, economic forces and cultural and symbolic factors. It is said, for example, that if man is to orient himself in the world, he must somewhere erect a fixed point, a center. It seems, therefore, that a centering process is capable of generating wholeness in the three-dimensional constellation

of spaces which form a building, in a garden, or a street, a neighborhood, and even a city (Fig. 5.12).

5.2.1.4 Boundaries

Related to both quantization and patternization is the presence of boundaries of one kind or another. The undelimited field emphasizes continuity while boundaries emphasize discontinuity. Consequently, systems, which have been described as, bounded regions in space-time with an interchange of energy among their parts, possess boundaries, which may be simple and

(a)

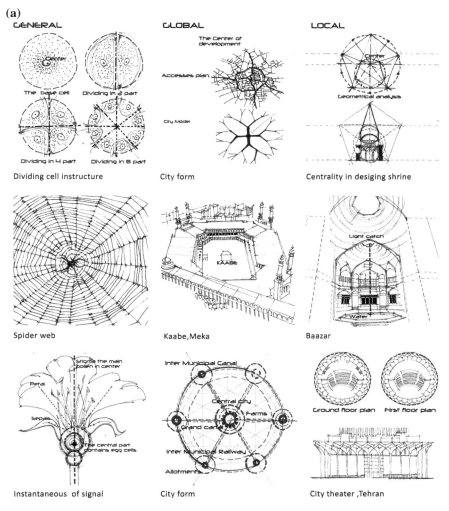

Fig. 5.12 **a** Centrality is a very common form of patternization. **b** Centrality in urban design may be said to originate from many sources such as religious impulse, economic forces and cultural and symbolic factors

clear-cut, as in the case of a tree, or non-material. Boundaries define spaces in the physical environment, which will in turn lead to identity, safety, security and freedom.

Boundaries are involved in the making of choices. In the natural landscape, geometrical discontinuities will often provide such boundaries and these physiographical boundaries are retained or directly related to man's goal-seeking within that environment, and to his technological capabilities to attain such goals.

Boundaries provide diversity of choice and opportunity in the form and function of the environment. Boundaries, either spatial or temporal, make the environment live and dynamic, since they are the source of change and movement. Boundaries in urban form may appear in the form of edges, surfaces, lines, etc. which differentiate two or more different but adjacent urban forms. These differences in urban form can be in density, height, topography, intensity, style, color, materials, relationships or any combination of these and other elements. In the case of perceptual processes, there could be boundaries that might not be tangible or sensible to some observers but which could be sensible and identifiable to others.

(b)

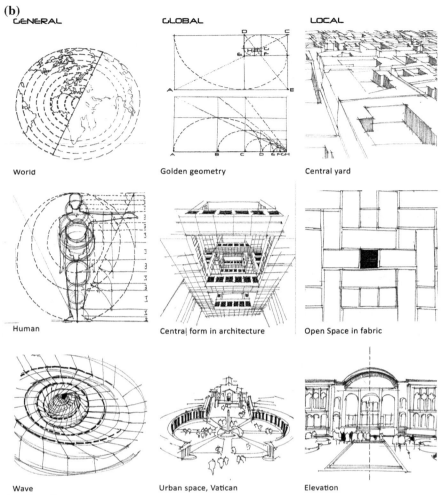

GENERAL	GLOBAL	LOCAL
World	Golden geometry	Central yard
Human	Central form in architecture	Open Space in fabric
Wave	Urban space, Vatican	Elevation

Fig. 5.12 (continued)

Perceptual boundaries, therefore, can be images rather than concrete forms. An optimum combination of these elements in the physical environment results in complexity, diversity and cohesiveness (Fig. 5.13).

5.2.1.5 Territories

Territories are also part of the principle of boundaries. They deal with the division of the environment into spatial or temporal regions, symbolically controlled by various individuals or groups, within which certain types of behavior are expected. A simple and familiar example is the division of the environment into private and public spaces.

This principle deals with boundary, borders, domain, realm, sphere, privacy, and sense of belonging, sense of place, possession, ownership, and defensible space. This division could be temporal or spatial, i.e. I world versus others' (it) world. One can also find natural, political, administrative, economic, and functional boundaries in the environment. Some territories are simply visible, while others are only perceptual (invisible). There are various tools in architecture and urban design to define and divide territories, such as walls, fences, doors, gates, etc.

Main characteristics of territories include: Identity, defining and limiting, allocation, defining

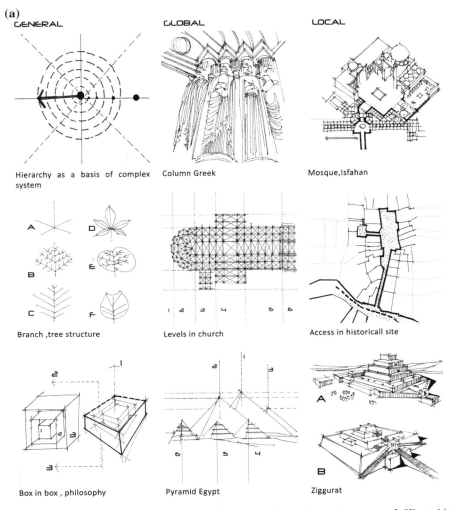

Fig. 5.16 a The notion of hierarchy lies in the nature of very complex and evolving systems. b Hierarchical order is the most natural way for ordering dynamic phenomena

regional planning. The essence of this principle has been applied on a smaller scale to city design. The hierarchy of movement system in downtown Philadelphia and the concept of the essential/nonessential are two examples (Fig. 5.16).

5.2.1.8 Equilibrium

This principle deals with all the dynamic and organic systems in the environment. The relationship of man to his environment is subject to continual and restless change from generation to generation, from year to year, and from instant to

instant. This relationship is in danger of becoming disequilibrated.

There is n static equilibrium between Man and his environment or between inner and outer reality. The process of equilibrium is equilibration. Manipulative forms of equilibrium require the presence of two kinds of feedback, one negative (deviation-corrective) and the other positive (deviation-amplifying). Negative feedback tends to dominate the maintenance of equilibrium (socio-cultural, for example) at any given level. Positive feedback is required to move from one level to another.

(b)

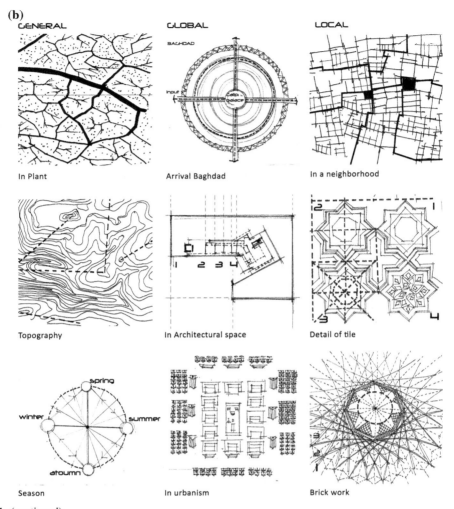

Fig. 5.16 (continued)

Both negative and positive forms of equilibrium are always at work in the environment. Knowledge of the way in which they function in the decay and growth of metropolitan complexes is vital for urban designers.

The equilibration process governs the relation of man to his environment. Inorganic and Organic phenomena alike exist simultaneously in time and space and indeed with in a fused Time —space continuum. In progressively organizing and controlling his environment, Man has, therefore, involved himself with the continuous interplay of phenomena on the temporal and spatial dimensions. When human functions relate primarily to the spatial dimension, man Conceptualized models and fabricates tools essentially to attain environmental control by using techniques for the organization of space.

Techniques to attain environmental control deal with the relationship of Man-to-environment and Man-to-Man. Hence, these techniques are related to temporal as well as to biological factors. The social techniques comprise the tools or methods by which a community seeks to organize and retain environmental equilibrium. Examples of these are religious and philosophical concepts, legal codes, administrative systems, caste systems, ecclesiastical hierarchies,

educational systems, economic institutions, etc. The principle of equilibrium implies that individuals, societies and their natural and built environment, as dynamic systems, are always in the process of change and self-correction. Self-correction is in the direction of equilibrium but equilibrium is not, of course, stable. The principle can also be applied to the evaluation of physical environment. The form of the city is subject to change and evolution. Some of the controls are deliberate and planned, but in general they go through incremental changes. When the conditions of disequilibrium are amplified, this might cause a shift to the next level of equilibrium. This, of course, would only be temporary. Urban design plays a significant role in the process of control and amplification.

The changes that take place in the environment are orderly, i.e., they move and fluctuate within bounds. To go beyond the limits that are set (culturally, naturally, and ecologically) is to bring about destruction out of which, however, arise new bounds, restored equilibrium and a new order. Contrasting binaries of lack of fullness, openness, and closure create balance and counterbalance. These conditions are not static or mechanical. In the process of living in the environment, individuals and institutions adjust to the environment and tend toward a state of harmony and equilibrium (Fig. 5.17).

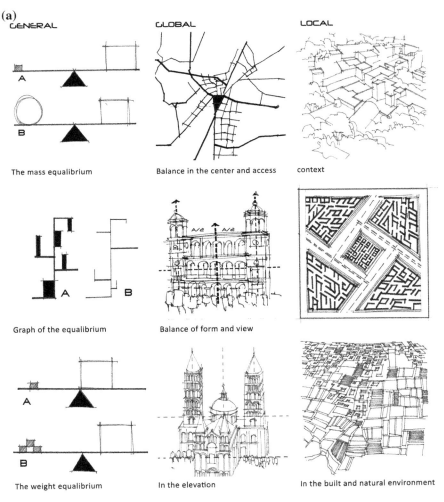

Fig. 5.17 a Equilibrium deals with all the dynamic and organic systems in the environment. **b** The equilibration process governs the relation of man to his environment

(b)

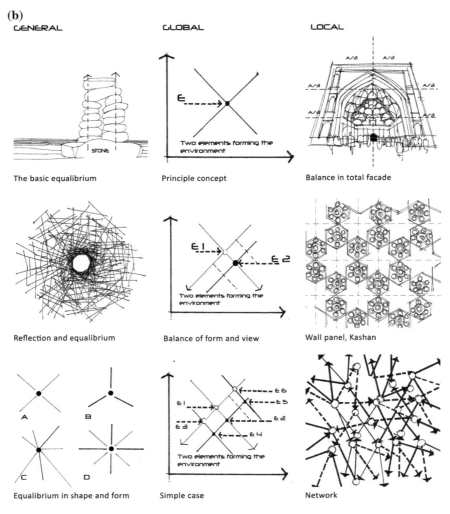

Fig. 5.17 (continued)

5.2.1.9 Cybernetics or Environmental Feedback

Cybernetics or the science of feedback and control has tremendous potential for application in the urban design of the future. This is so because it is based on the ability to rapidly process an enormous amount of information and thus facilitate the making of appropriate decisions. It further conforms to the principle of self-correction. Such a device compares a current state of functioning with desired goals and adjusts performance on the basis of the observed differences.

Urban cybernetics, or the concept of environmental feedback, is indispensable in the complex environment of today. Each individual in this environment is in the midst of receiving, interpreting and sending huge numbers of signals and symbols as messages. The channels through which these communications flow are many and diverse, ranging from the very primitive devices of traditional cities to the most advanced electronic media of today. All of these sophisticated and complicated processes are sources and channels of actions and reactions, which result in the formation of the urban environment.

(a)

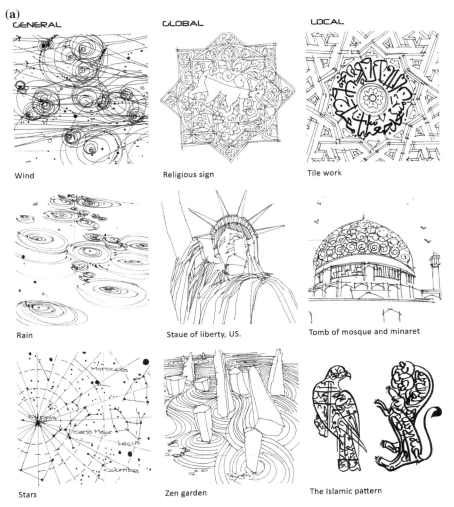

GENERAL	GLOBAL	LOCAL
Wind	Religious sign	Tile work
Rain	Staue of liberty, US.	Tomb of mosque and minaret
Stars	Zen garden	The Islamic pattern

Fig. 5.19 **a** The fundamental idea of semiology in urban design is that any form in the environment is motivated or is capable of being motivated. **b** Semantics, metaphor and analogy help to understand the world through interpreting certain regularities in imagination and creative thought

Insight is the understanding that occurs when the situations reorganized in such a way as to become transparent—that is, when the essential features and the reciprocal relations are clearly and directly apprehended (Fig. 5.20).

5.2.1.16 Context and Culture (Localization)

The principles mentioned here as the rules and principles of urban design language, were intentionally thought of and formulated in such a way as to be abstract, general and universal. Their application in a specific environment, however, requires that great effort be made to modify them for that particular environment. In fact, there are very few of these principles that have universal applicability in the form in which they have presented here. Most of them, rather, are general principles which might be meaningless in certain environments unless they are modified and tested specifically for that specific culture or context. Each principle is described in an open and flexible way which can take on a variety of forms. It is the culture or context that makes them particularly meaningful (Ozgood and Tzeng 1990).

(b)

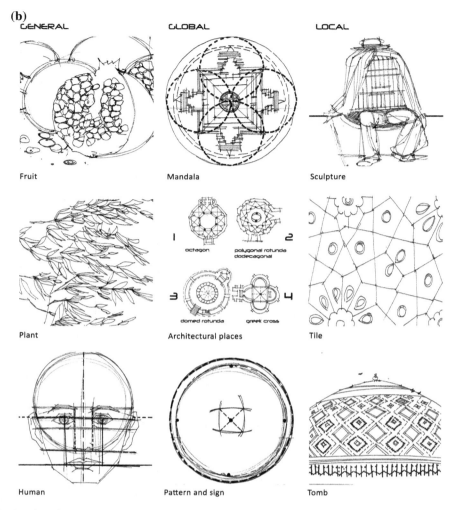

GENERAL	GLOBAL	LOCAL
Fruit	Mandala	Sculpture
Plant	Architectural places	Tile
Human	Pattern and sign	Tomb

Fig. 5.19 (continued)

Lynch (1981, p. 101) states that physical patterns may have predictable effects in a single culture, with its stable structure of institutions and values. But it is not possible to construct a cross-cultural theory. It is even dangerous, since it will inevitably be used to impose the value of one culture on another. Each culture has its own norms for city form, and they are independent of those of any other.

Since the behavior patterns of different groups of individuals in different cultures varies, we may, therefore, conclude that their ways of life, their relationships with space and their interpretations of it also differ. This will imply the eventual need for specific rules and principles which are based on the value systems, aspirations, needs and problems of a particular culture.

Depending on the culture in question, for example, the formal patterning of space and activities can take on varying degrees of importance and complexity. The organization of space, territory, boundaries, etc., is an important aspect of urban life which is closely tied to the attributes of the culture. It is for example, known that privacy can be defined only in a specific cultural context. What is regarded, as a private place in a particular culture might be considered semi-private or even public in another.

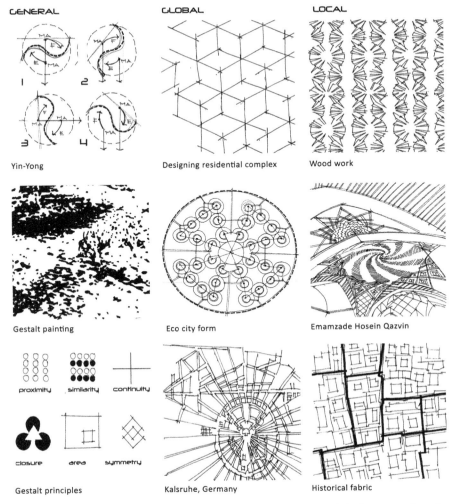

Fig. 5.20 Gestalt principle is based on the claim that the meaning of the whole is greater than the sum of its components, or stated differently, that whole is greater than the sum of its parts

A similar cultural variability governs the interpretation and meaning of the space that contains the activities.

Culture is represented by certain shared values and interests. It comprises all aspects of a shared appreciative system, which is carved out by interests, structured by expectations and evaluated by standards of judgment. It is also a communication system of shared value. It is the shared values that modify these principles for the purpose of local application. Common symbol systems may be used as a clue to those values and interests.

A culturally specific urban design requires a culture-specific language of urban design based on culturally modified principles.

A characteristic of the present time is that worldviews must come to terms with the increasing exaggeration of both the global and the local. Urban designers should be in command of following knowledge and skills (Bull et al. 2007, p. 228):

- The ecology and dynamics of natural and urban systems at a global, regional and local scale,

- The technologies of conservation, management and construction in the urban, suburban and natural domains (including 'sustainable technologies' as they evolve)
- The history and theory of practice, including the failures and successes of various projects in conserving, managing and constructing natural and urban areas
- Spatial analysis of the processes of change that are manifest as urban areas and landscapes globally, regionally and locally; past and present
- Conceptualizing the form and function of future, alternative territories et al. scales

- Converting concepts into realizable urban projects, whether a the strategic or site scale
- Communicating as cultural and cross-cultural practitioners across a wide range of territories; and
- The organization, legal framework and ethics of practice, globally and locally (Fig. 5.21).

5.2.1.17 Sustainability

Sustainable urban design is vital for this century, our health, welfare and future depends on it. We will need to develop flexible ways to 'shape' and design our future cities. Sustainable urban design is about balance—in uses, density,

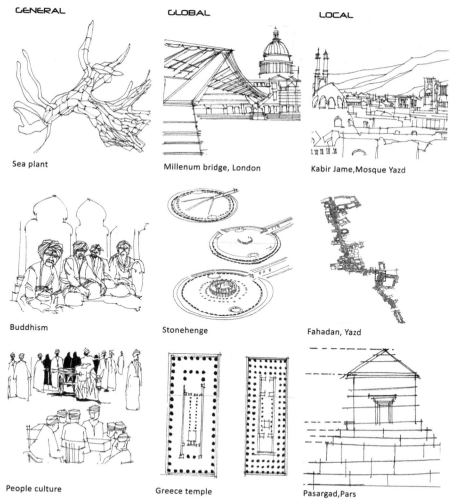

Fig. 5.21 Application of principle in a specific environment requires that great effort to modify them for a particular environment

transport, diversity, and natural and man-made environments.

To some sustainability implies self-sufficiency. There have been attempts to build self-sufficient villages often in remote rural areas. These are described by the Gaia Foundation as 'human scale, full featured settlements which integrate human activity harmlessly into the natural environment' a worthy goal for any urban neighborhood (Eco-Village Foundation, 1994). These settlements grow their own food, generate their own power, and recycle their waste; coming as close as it is possible to an environmentally benign human settlement. But these are too small in scale and demand time and commitment from their members. In the case of cities, however, there are many who believe that cities are environmental disasters and have no place in a sustainable future that is until we consider alternatives. More than half of the world's population now live in cities so that it is hopelessly unrealistic to postulate a city-free sustainable future (Rudlin and Falk 2009).

Some principles are:
- Reducing input
- Using local resources
- Minimizing waste
- Making use of urban economies
- Walkability
- Personal safety
- Legibility
- Taming the car
- Creative congestion
- Higher density
- Public transport
- Reducing energy use
- Recycling
- Providing green space
- Mixed uses

Some of the urban design principles suggested for sustainable urban environment are (Thomas 2003):
- Sustainable urban structure, which deals with urban regions, the town or city and its rural and/or coastal hinterland.
- The walkability
- Planning and design implications and opportunities

- Streets and street blocks, to enable direct pedestrian movement
- Optimizing development density
- Some density rules of thumb
- Some broader issues and key points, such as socially mixed and inclusive communities, provision of services and facilities that meet a range of needs, engaging local communities in discussion about how they see their neighborhood and their priorities and aspirations for the future, provision of quality public transport services, the delivery of excellent local facilities and services, recognition that long-term management and maintenance are as important as the initial design and the vision of new development as catalyst for the improvement of existing areas (Thomas 2003, p 23).

Bioregionalism has emerged as the new framework to study the complex relationships between human communities and the natural world. Bioregionalists believe that as members of distinct communities, human beings cannot avoid interacting with and being affected by their specific location, place and bioregion (Mc Ginnis M. V. 1999).

One of the principles outlined by Berg and Dasmann (1977) for bioregionalism is living-in-place, which means following the necessities and pleasures of life as they are uniquely presented by a particular site, and evolving ways to ensure long-term occupancy of that site. A society which practices living-in-place keeps a balance with its region of support through links between human lives, other living things, and the processes of the planet—seasons, weather, water cycles—as revealed by the place itself. So one has to learn to live-in-place in an area that has been disrupted and injured through becoming aware of the particular ecological relationships that operate within and around it. A bioregion can be determined initially by use of climatology, physiology, animal and plant geography, natural history and other descriptive natural sciences (See also: Atkinson 1992 and Aberley 1994) (Fig. 5.22).

5.2.1.18 Economics

Today the city is more than ever shaped by economic forces (Frey 1999, p. 1). Today's city

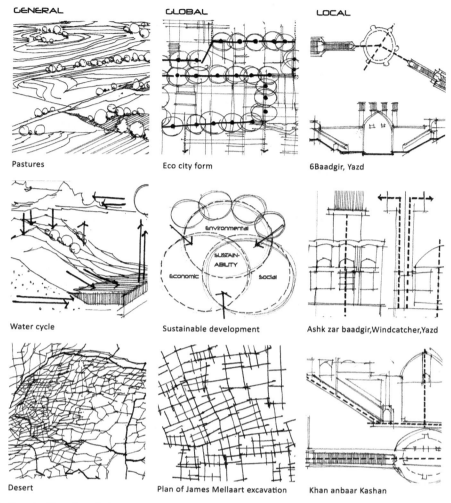

GENERAL

GLOBAL

LOCAL

Pastures

Eco city form

6Baadgir, Yazd

Water cycle

Sustainable development

Ashk zar baadgir,Windcatcher,Yazd

Desert

Plan of James Mellaart excavation

Khan anbaar Kashan

Fig. 5.22 Sustainable urban design is vital for this century. Our health, welfare and future depends on it

is shaped by the communications and transport technology we use, and by market forces. In England, urban areas provide for 91 % of the total economic output and 89 % of all the jobs (Final Report of the Urban Task Force 1999). So valuation for sustainability cannot be separated from idea 0f actions whose effect is to sustain this or that form of life—in the cultural as well as ecological—economic sense (Abazaand Baranzini 2002, p. 33). It is for this reason that maintaining and improving the economic strengths of the towns and cities is therefore critical to the competitive performance of the country as a whole.

The planner's triangle, a model of sustainable development designed by Scott Campbell (1996), is based on three pillars: ecology, economy and equity. A knowledge of the structure and functioning of the urban economy is, therefore, fundamental to all urban design analysis and decisions. The density of an urban center is controlled by the extent and character of its productive and income-producing activity and its general vitality. Most metropolitan areas flourish because they serve as centers for production and distribution of goods and services, production and distribution functions create jobs, and employment opportunities attract people.

Crookston (1996) raising the question of: Urban design and urban economics: just good friends? From a review of a small group of settings concludes that urban design thinking has made a real and integral contribution. Three things have to be done: Urban design needs to be better integrated into consultants' teams than it often is, sitting alongside urban economics as a discipline; and the successful projects show that it can. Urban design needs to be better integrated into the development control process than it often is. Urban economist need to be part of that integrated, collaborative approach too, working in a positive way to define the financially feasible and the economically sustainable, helping to overcome problems not just pointing out their existence.

- Land uses
- Activity locations
- Density
- Quality and quantity of infrastructure
- Job opportunities
- Taxation
- Financial resources
- Information and telecommunication technology

The marriage between telecommunications and computing along with the infrastructural networks for digital transformation of data, voice, image, and video—collectively known as information and telecommunications technologies (IT)—is increasingly gaining relevance as a new dimension of cities. This dimension is partly physical and partly invisible and is forcing a reconceptualization of traditional urban models of city form and growth (Audirac 2002). These transformations posit a new kind of city that Hall (1997) describes as: globalized (connected to other cities in global networks); tertiarized and even quaternarized (dependent almost entirely for economic existence on advanced services); informationalized (using information as a raw material); and polycentric (dispersing residences, and decentralizing employment into multiple centers or edge cities. IT will affect the locational decisions of firms and households by dissolving the importance of distance and permitting foot-loose economic activity to relocate to lower-cost exurban, rural and offshore areas. Telecommuting is working as a substitute for commuting trips. Workers substitute some or all of their working day a remote location (almost always home) for time usually spent at the office (Wheeler et al. 2000). Firms will reduce office space costs, whereas telecommuters will have more freedom of choice in residential location. Depending on the density and frequency of office-trip substitution, telecommuting can contribute to the lowering of traffic congestion and ultimately to fewer carbon emissions.

Among the information and telecommunication tools the Internet has had the greatest, far reaching, and most permanent impact on the world economy and the transformation of society. As Castells puts it: our historic time is defined by the transformation of our geographic space.

Within cities, cyberspace contributes to a substantial reconstruction of urban space, creating a social environment in which 'being digital' is increasingly critical to knowledge, wealth, status, and power.

Castells (2000) has introduced a particular model of spatial organization, which, according to him, is characteristic of the Information Age, as the space of flows. He defines space of flows as the material arrangements that allow for simultaneity of social practices without territorial contiguity. It is made up of: (1) technological infrastructure of information systems, telecommunications, and transportation lines; (2) nodes and hubs; (3) habitats for the social actors who operate the network; (4) comprises electronic spaces such as Web sites, spaces of interaction, as well as spaces of one-directional communication. The growing use of telecommunications systems is doing far more than influence where people work and live, but is actually changing the character of activities that occur in the home, workplace, automobile, and the street. Telecommunications has made the fundamental elements of urban life—housing, transportation, work and leisure—far more complex logistically, spatially, and temporally (Moss, and Townsend 2000).

It seems, therefore, quite essential to consider IT and Telecommunications as an integral part of any urban design decision, and take their

implications on urban design elements into considerations.

5.2.1.19 Globalization

The essence of globalization could be defined as the unrestricted movements of money, people, information, and culture. These agencies will have their effects on the components of urban form—urbanism, image and identity, spatial organization and structure, social ecology, public realm, scale and pace of development, and architectural vernacular. This process is especially significant in the case of the third world countries, where the conventional model of city becomes obsolete and cities are beginning to look more and more like that in the West (Pizarro et al. 2003).

Capital flows across the globe have markedly increased; a vast array of cultural products from different countries have become available in one place; and the nation-state is no longer the only entity that affects people's political life and ideas. Economy, culture, and polity are being transformed, reshaped and reworked to produce a more global world and a heightened global consciousness. Globalization takes place in cities and cities embody and reflect globalization. Global processes lead to changes in the city and cities rework and situate globalization. Contemporary urban dynamics are the spatial expressions of globalization, while urban changes reshape and reform the processes of globalization (Short and Kim 1999).

5.2.1.20 Process

Design is inherently a procedural entity, or a process. The concept of a process is widely present in various literature and design manuals, which attempt to produce a definition for design in general or urban design in particular. Intact, the concept of process is the core element of all these definitions. A process, which is normally considered as a continuous action, operation or series of changes that take place in a continuous manner, seems to be very relevant to any design activity. What is important is that design is a purposeful process that starts with some sort of objectives, and ends up with an outcome that responds to them.

Design process has always been a problematic and sensitive subject for designers. Many designers emphasize the art of design; that is, they seek expression of the intuitive and creative design capabilities of the individual designer. Others emphasize various systematic processes and take a philosophical approach to design (Shirvani 1985).

There have been a number of efforts to model the process and procedures of urban designing (see for example: Barnett 1966; 1982; Shirvani 1985; Steinitz 1979; Halprin 1969; DeChiara and Koppelman 1982; Bahrainy 1998; Lang 2005).

Most generic models suggest a rational step-by-step procedure that moves from perceptions of a problem to post-implementation evaluation of a completed work. While the models give some structure to our thinking and to our design of the decision-making appropriate to a job at hand, urban design does not take place in the neat sequential manner that the models suggest. Urban designing is an argumentative process in which participants in it learn as they go along. They learn about goals and means as perceived by different stakeholders, they learn from the evidence that each provides for its views. Application of process in urban design makes public involvement possible, prevents mistakes, makes generating alternatives and choice possible, makes issues understandable to the public and authorities, helps resolving conflicts and make consensus, facilitates implementation and effectuation, and finally it is inevitable for an activity as complex as urban design (Fig. 5.23).

5.2.1.21 Participatory and Collaborative

As there is a move toward equitable distribution of resources and opportunities, there is a move toward a broader consensus on the control and distribution processes. This ultimately leads to the 'user,' or citizen, and can take the form of participatory planning and design (Smith 1973). There is a clear trend not just towards public consultation in design matters, but towards the public defining the principles of control and contributing to the administration of the control

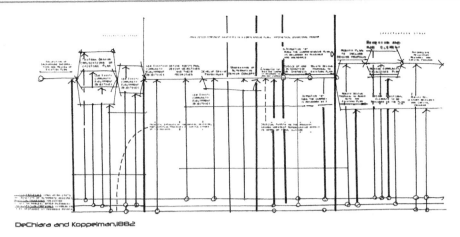

DeChiara and Koppelman,1982

Fig. 5.23 Design is inherently a procedural entity, or a process

process itself. Such ventures provide a mechanism for managing disputes, and for giving the community far greater 'ownership' of the control mechanism (Punter 1999, p. 503). Community involvement in the process of urban design is increasingly promoted as a means of overcoming —or at least reducing—the professional-layperson, powerful powerless and designer-user gaps. Participation takes many different forms, broadly conceptualized as top-down or bottom-up approaches (Carmona et al. 2003, p. 485, see also Bahrainy and Aminzadeh 2007, p. 241–270)

Participation makes dialogue, as 'the free flow of meaning between communicating parties, possible. There are some who emphasize the creative nature of dialogue as a process of revealing and then melting together the rigid constructions of implicit cultural knowledge. Forester (1989, 119–133) has addressed the issue of participation with the concept of 'designing as making sense together'. With the concept he refers to the notion of designing as a shared interpretive sense-making process between participants engaged in practical conversation in their institutional and historical settings.

According to Forester, such design work is both instrumentally productive and socially reproductive. Participants, however, may share a concern, but arrive at it through different cultural, societal and personal experiences. They belong

to different 'systems' of knowing and valuing that will remain nearer or farther from each other in relation to access to each other's languages. Design communication should therefore focus on reaching an achievable level of mutual understanding for the purposes at hand, while retaining awareness of that which is not understood (Healey 1992, p. 154).

The term collaborative design feature as an increasingly prominent part of the vocabulary used in the range of planning and design literature. According to Healey (1997) collaborative planning and design is about why urban regions are important to social, economic and environmental policy and how political communities may organize to improve the quality of their places. Collaborative design is intended to serve as both a framework for understanding and as a framework for practical action.

Dobbins (2009) states that' the people who live where place improvement is happening must be involved; the disciplines whose work shows up in the process must coordinate; and the public-private partnerships that drive design and development in the public realm must work more aggressively to include the community voice. From the practical point of view, Brown et al. (2009, p. 111) explain how public involvement in the decision-making process was actually taking place in the case of AIA Urban Design winning projects. The process, they explain,

began by identifying the kinds of participants to be included and laying out an approach intended to draw them into the process. Common mechanisms included community task forces, workshops, regular public meetings, charrettes, or some combination of all of them.

5.2.1.22 Methods of Inquiry— Qualitative, Artistic and intuitive methods

The last two principles have a two-fold function in the urban design language. One is the role they play a specific tools of analysis and synthesis. More important, however, is the role they play as the modes of thinking, the ideological framework of urban design process, decision and action.

Intuition, as both a method of analysis and synthesis, plays a critical role in urban design. As a method of analysis and synthesis, it can be best applied to those areas of urban design, which are, by their nature, subjective, qualitative and subject to personal interpretation, modification and attitude. The perceptual, visual and aesthetic aspects of urban form, and these processes which govern the relationship between man and environment are in the realm of intuitive analysis and judgment.

As a way of thinking, intuition plays a still more critical role in urban design. It attempts to integrate and unify all the various scientific and non-scientific methods into an integrated and unified language of urban design. Intuition in this regard, provides a holistic and gestalt perspective of the subject (urban form and urban activity systems), i.e., it considers all its parts and links simultaneously. It is thus a model of analysis and synthesis which stands against reductionism and, therefore, properly represents the reality and complexity of urban life. Intuition weaves the diversified methods and processes of urban design together as integrative tools and makes them more effective in their application.

5.2.1.23 Methods of Inquiry— Quantitative, Scientific and Objective Method

According to Fecht (2012) urban designers traditionally have doubted the role that science can play in describing or predicting or fixing a city. They assert that cities have an emergent complexity those results from the interactions among people as well as between people and the environment, and that there is an element of human behavior that cannot be reduced to an equation. To survive Marshall (2012) argues that the field needs to incorporate scientific training into its educational curricula, and cultivate "a concern for testing and validation, critical assimilation of scientific findings from disparate sources, and dissemination of the most reliable, up-to-date findings." But as cities grow and researchers continue to elucidate the influence of design on factors such as carbon dioxide emissions, physical activity and quality of life, there will be an inevitable shift toward scientific thinking. The basic need for urban design to make use of 'urban science' (Moudon 1992) or the 'science of cities' (Batty 2012) is for practical purposes uncontested.

The scientific method also plays a two-fold function in the process of urban design. As a way of thinking, the scientific method provides urban design language with rationality, perception and clarity. Given the complexity of the present urban environment as well as the nature of the democratic decision-making processes, the need for processes based on the scientific method is evident.

The scientific method, therefore, provides urban design with the reasoning aspect of thought. The interpretation of intuitive and reasoning modes can, however, create a more powerful, productive and creative context of thinking and ideology for urban design. The two, one with subjectivity, holism, originality and creativity and another with objectivity, rationality and universality can complement each other's deficiencies and shortcomings. This would imply the integration of emotion, feeling, and senses with the intellect, understanding and rational thought.

The second role of the scientific method in urban design is its effectiveness in providing effective tools and techniques for analysis, explanation, prediction, verification and evaluation of issues in urban design.

Applying these rules and principles, we may now define urban design as: The process of purposeful application of these integrative principles to the substantive elements of urban space and urban activity circuits to construct larger urban structures with the goal of creating formal and functional order in the urban environment.

Scientific thinking as logical thinking, as problem solving, as induction and as everyday thinking (Kuhn et al. 1988). But as Kahn (1969) says 'the measurable is only a servant of the unmeasurable, and ideally the two would be developed together.

5.2.1.24 Integrative Methods of Inquiry

It should be pointed out that according to Habermas it is a combination of three cognitive areas in which human interest generates knowledge that could lead to better understanding (analysis) and design (synthesis). They are: (1) work knowledge which refers to the way one controls and manipulates environment. This is commonly known as instrumental action—knowledge is based upon empirical investigation and governed by technical rules. The criterion of effective control of reality direct what is or is not appropriate action. The empirical-analytic sciences using hypothetical-deductive theories characterize this domain. Much of what we consider 'scientific' research domains—e.g. physics, chemistry and biology are classified by Habermas as belonging to the domain of work. (2) Practical knowledge: the practical domain identifies human social interaction or 'communicative action'. Social knowledge is governed by binding consensual norms, which define reciprocal expectations about behavior between individuals. Social norms can be related to empirical or analytical propositions, but their validity is grounded 'only in the intersubjectivity of the mutual understanding of intentions'. The criterion of clarification of conditions for communication and intersubjectivity (the understanding of meaning rather than causality) is used to determine what is appropriate action. Much of the historical-hermeneutic disciplines—descriptive social sciences, history, aesthetics, legal, ethnographic literary and so forth are classified by Habermas as belonging to the domain of the practical. And (3) Emancipatory knowledge: the emancipator domain identifies 'self-knowledge' or self-reflection. This involves 'interest in the way one's history and biography has expressed itself in the way one sees oneself, one's roles and social expectations. Emancipation is from libidinal, institutional or environmental forces which limit our options and rational control over our lives but have been taken for granted as beyond human control. Insights gained through critical self-awareness are emancipator in the sense that at least one can recognize the correct reasons for his or her problems. 'Knowledge is gained by self-emancipation through reflection leading to a transformed consciousness or 'perspective transformation'. Examples of critical sciences include feminist theory, psychoanalysis and the critique of ideology, according to Habermas.

Summary of Habermas' three domains of knowledge

Type of human interest	Kind of knowledge	Research methods
Technical (prediction)	Instrumental (causal explanation	Positivistic sciences (empirical-analytical methods)
Practical (interpretation and understanding	Practical (understanding)	Interpretive research (hermeneutic methods)
Emancipatory (criticism and liberation)	Emancipation (reflection)	Critical social sciences (critical theory methods)

(See: Roderick 1986; Schroyer 1973; Healey 1996; Forester 1993)

Summary of Habermas' three domains of knowledge Habermas' three domains of knowledge their related methods have very strong and meaningful implication for the practice of urban design. In fact the very nature of the field of urban design makes the integrative application of these methods inevitable.

Conclusion

6

There is ample evidence today to show that man, from the beginning of civilization and throughout history, has sought to gain some kind of control and impose some sort of order on his/her physical environment. Although these general goals of control and order have basically remained the same in time, their meanings, interpretations and means through which control and order are attained, have been constantly changing. In every period of history, the needs, preferences and aspirations of a society have been the determinant factors that defined and specified the means to and ends of those general goals. The Industrial Revolution brought about a turning point in the nature of the means and ends pursued in urban design. The traditional artifact gave way to the giant megalopolis: the artistic subject of civic design was transformed into the scientific area of urban design and city planning; and the purpose of designing cities changed from magnificent levels of achievement and artistry to practical efficiency, comfort and justice in the cities. Today the subject matter of urban design includes form as well as function, aesthetics as well as efficiency and process as well as product. The means to these ends have to be also modified accordingly.

The knowledge base of urban design contains the means for achieving the established goals. Recognition of this knowledge base and its components seems to be a significant step toward a better understanding of the ends, the means and means-ends relationship in urban design.

The knowledge base of urban design, as any other field, consists of two major elements: Procedural elements, which deal with the *know-how*, and the substantive elements, which deal with the *know-what* of urban design. Against the traditional view it was argued that intuitive methods should be applied to formal elements and scientific methods to functional elements. Moreover, it was suggested that the integration of intuitive and scientific methods can result in a more powerful and effective tool for urban design.

It was suggested in Chap. 2 that the primary concern of urban design is with formal aspects, i.e., urban form and its perceptual and visual attributes. But urban form, as the container of urban activities, is not separable from its content, because there is always a reciprocal but complex relationship between the two. Urban activities, therefore, are regarded as the secondary concern in urban design. The knowledge base of urban design, therefore, consists of urban form, urban activity systems and the integrated intuitive and scientific methods.

The bulk of knowledge in any area of discipline is generally too vast and unorganized to be mastered by anyone interested in a particular area. There is need for an instrument or tool to facilitate the acquisition of this knowledge, the ability to communicate with it, develop it and apply it. It is only language, in its broad sense, that can play such a critical role. Language is the key to knowledge. It is the tool of communication and representation. The knowledge base of

© Springer International Publishing Switzerland 2016
H. Bahrainy and A. Bakhtiar, *Toward an Integrative Theory of Urban Design*,
University of Tehran Science and Humanities Series, DOI 10.1007/978-3-319-32665-8_6

urban design, therefore, may be represented by the language of urban design. There are certain requirements and qualifications to be met by this language in order to be acceptable. The minimum requirements of any language are: Vocabulary, which are the smallest meaningful signs; and grammar or syntax, which are sets of rules and principles to be used in building larger structures. Besides these two requirements, there are also certain criteria to be met by those signs and rules if they are to qualify as legitimate elements of language. The language of urban design is formulated on the basis of these general definition, requirements and qualifications of language, and it is believed to exhaustively represent its knowledge base.

The vocabulary of the urban design language consists of two groups of signs, each representing one of the substantive areas of urban design. The first is urban space which represents urban form and its attributes. The second, the urban activity circuits, represents urban activity systems. Both of these are the smallest complete units of the subjects they represent, i.e., urban form and urban activity systems, and therefore, include the same characteristics.

The critical role of these signs is that they identify exclusively and inclusively, the very subject matter (substance) of the field by differentiating between the signs that represent urban design and other similar signs, such as architecture or urban planning. These signs will indicate the primary focus of the field as well as other related areas.

While signs of the language identify the specific scope and concern of the urban design, grammar or rules, on the other hand, provide the procedural tools to be used in the decision-making and action-taking of urban design. These rules deal with both formal and functional elements of urban design and are an integration of intuitive and scientific methods and processes. The rules are heavily interrelated and interdependent and, therefore, must be applied in an integrated manner.

The process of integrating these rules and also their applications to the substantive elements of urban design—urban space and activity circuits —require a unifying element. This we find in intuition. We may conclude here by pointing out that this study and its findings must be regarded as an introductory efforts which intends to introduce the knowledge base and language of urban design as a new approach to the development of the urban design theory. Extensive study is, however, needed to develop these findings further. Such efforts are particularly felt in the case of proposed rules and principles, in order to extend their practical and operational applications to an effective and meaningful level.

As mentioned earlier, the signs and rules were defined and formulated here in such an abstract form to represent the universal language of urban design. They are, therefore, value-free and their application in a particular environment is meaningless unless they are modified on the basis of the local conditions.

We may conclude by presenting a summary of the main points discussed in the book:
1. An integrative knowledge base of urban design, as the repertoire of the field, was introduced.
2. The global (universal), and local languages (theories) of urban design, and their related rules and principles were proposed on the basis of logical definition, with structures and criteria drawn from philosophy and linguistics.
3. The subject matter, realm, and scope of urban design was defined exclusively and inclusively.
4. The traditionally contradictory areas of form and function, and science and intuition were proposed to be integrated into a unified knowledge and language of urban design.

The proposed language (or theory) of urban design may be called integrative because it includes substantive (urban form, urban space and urban activities), as well as procedural (scientific, artistic and intuitive) elements. It is also integrative because it covers at least two levels of practice domain: global (universal) as well as local (culture-specific)

Appendix

Practical Implication of the Proposed Language of Urban Design

The principles of Quantization and Main Structure (as an implication of the unity-multiplicity and order-disorder principles).

The purpose of this part of the book is to show how some of the principles and rules mentioned as the components of the integrative theory of urban design may be applied in the practice of urban design. Several of those rules are frequently used by practicing urban designers, others, however, are not quite known to them. Here the principle of quantization, which is least known and applied by practitioners, and also the Main Structure concept, which has numerous potential applications, will be explained.

A. **Quantization** is based on two concepts of continuity and discontinuity. The concept of discontinuity was first introduced in nature by Quantum Theory[7] of Max Plank in 1900. The theory has since extended from mechanics to physics (radiation), chemistry (see Andrew and Kokes 1965) (electron, proton, and neutron), aggregated (crystals), thermodynamics, biology (Kendrew 1966), music (Rayleigh 1945), and art and architecture (Thiel 1968). In the physical environment one can find the complementary aspects of continuity and discontinuity in the form of fluctuation in the level of information (Buchanan 1974). In the structures made of these fluctuations (or waves), there are the complementary aspects of repetition and variation. The bundles of these waves are combined in the total structure to produce organic complexes that are more than the sum of the component parts (Gestalt). We will see that the physical environment provides patterns which follow the quantization rules. These rules will provide new insights into the correlation of ideas and concepts in urban design. Patterns and patternization are essential to all human senses and intellect. The ear becomes quasi-deaf to a continuous tone. Also, scanning is necessary to have any sensation of vision at all. The brain also demands patterns.

Neither a steady flux nor an unpatterned random flux can be organized into experience. Non patterned experience would most likely stall man's perspective and intellective processes.

For the purpose of this book, Quantization deals with the perceptual and visual aspects of the environment. Since some of the principles of information theory and communication theory will be used in this part, a brief description of the basic definitions and concepts of these two theories seem necessary. The fundamental idea in the information theory is that of stochastic process. A stochastic process is any system which gives rise to a sequence of symbols to which probability laws apply. A stochastic process is characterized by some degree of redundancy between 0 and 100 %. At the zero-redundancy extreme, all the symbols generated have equal probability of occurrence, and nothing that we may know about the history of the sequence makes the next symbol any more predictable. At the opposite extreme, at 100 % redundancy, symbols are

© Springer International Publishing Switzerland 2016
H. Bahrainy and A. Bakhtiar, *Toward an Integrative Theory of Urban Design*,
University of Tehran Science and Humanities Series, DOI 10.1007/978-3-319-32665-8

0% Redundancy 100% Redundancy

Fig. A.1 The minimum and maximum level of redundancy

generated in an altogether lawful and regular sequence, such that one can predict with complete certainty what the next symbol will be (Fig. A.1).

Although the most interesting sequences fall somewhere between these two extremes, it is instructive to consider the variety of ways in which a sequence may be completely redundant. The simplest kind of complete redundancy occurs when one symbol has a probability of one, and others have zero probability, so that the sequences is of the form AAAAAAAA... This may be called the first order of redundancy, while ABABABABAB... Is the second order of redundancy, and, AABBAABBAABB... is the third order redundancy, and so forth, to the Nth order of redundancy. Prediction of a given symbol depends upon a knowledge of the one, two, three, etc. of the preceding ones. Communication theory was first formulated systematically by Claude Shannon in a paper entitled 'A mathematical theory of communication' (Shannon 1949). The flow of information, of all kinds, is the source of activities and actions changing our environment. On the basis of what we perceive from our environment we modify our actions which lead to changes in that environment. This is of course a mutual and reciprocal relationship (Rapoport 1976). We change the environment according to our needs and desires, but at the same time we are affected by environment in many ways. It is a dynamic and ongoing activity. In general terms, we have communication wherever one system, or a source, influences the states or actions of another

system, choosing the destination or receiver by selecting among alternative signals that can be carried in the channel connecting them (Ozgood et al. 1957, p. 272). On the basis of this definition, therefore, there will be at least four elements which are involved in a communication activity.

This mode of communication is the one-to-one mode, while there are also several other types of communication commonly used: one-to-many (TV messages), one-to-himself (one individual being simulated by the symbols he produces himself), and, many-to-one (one person using all sources of information: parent, teacher, TV, media, etc.).

All of these modes will be working in our case, in one way or another. The relationship between person and environment is multi-dimensional and complex. It is more of a cybernetics nature, than single linear one (Fig. A.2).

Transmission of a message from S to R requires using signs[10] and symbols (sign system)[11]. Actually, the message itself is a group of signs and symbols put together in a certain order. The sender encodes the message or the information through the channel he is using and the receiver decodes that. The signs used for this purpose should have the same significance (meaning) for the sender and receiver, otherwise communication is not complete.

Meaning is certainly involved at both the initiation (the intentions being encoded by the source) and the termination (the significances being decoded by the receiver) of any communication act. Meaning is related to mutually

Fig. A.2 Four elements of a communication process

inhabitants. It is natural to believe that each group of residents (of a house) are unique in their values, needs, wants, desires, and other characteristics. The second house next to the first one, therefore, will have some physical features which are different from the first one, based on these differences. The same will be true for the third house, and so on. A viewer or perceiver will be exposed to a different level of uncertainty by looking at these houses. Each house will give new information to the viewer, but there will be also some shared information between two adjacent houses, which provides continuity and consistency in the information one receives. Information may be, then, equated with meaning. According to Gestaltists, therefore, the combination of two houses creates a meaning, greater than the sum of the individual house. It is such accumulation of information, or meaning that create the sense of neighborhood.

It is not only the symbolic appearance of houses which will be the sources of information (to remove uncertainty), but also the pattern and structure of the block or neighborhood may be designed and arranged in a way to enhance the amount of information it gives to a certain desirable level (Fig. A.9).

In (b), for example, the layout of the block, or district, does not provide any new information. In the second case—(a)—another dimension of new information has been added to the previous one—that is the perception and feeling of space as one moves through the space. In b, although the individual units are sources of new information, because of the way they are lined up along two straight lines, they lose a lot of information because the channel of transmission is overloaded. This will eventually lead to an inefficient perception, and communication (high degree of redundancy). In b, on the other hand,

Sequences of impression ; associative relations established by the percipient. Markoffian perceptual processes

Fig. A.9 Two different layouts (**a**, up and **b**, down) in a neighborhood, based on two different levels of information created

the amount of information the viewer receives in any point in the path is limited to a certain level, and therefore, its efficiency is very high. The most important point about this approach is that, by application of stochastic models and the Markovian chain, we can measure and quantify the perceptual aspects of the environment. The volume of information is called entropy, and comes in bits. Perceptual variables, of all kinds, may be translated into measurable information units. At each point, then, we will be able to determine the probability range of what come next. At a still further stage we may also be able to include another variable into the model. The perceptual process also depends on the speed of the viewer (see Arnheim 1969; Appleyard et al. 1964; Halprin 1969). The higher the speed of the viewer, the more the amount of information one receives, and vice versa. The redundancy level will be, therefore, different for a path designed for pedestrians, and the one designed for motor vehicles. A path designed for pedestrians might be redundant and uninteresting for drivers, simply because the amount of information one receives from the environment in each case is different. B. Main Structure will be explained through a hypothetical design process for a neighborhood. Neighborhood planning and design have gained special value for urban designers, not only because the essence of neighborhood is lost in today's cities, but also because it is the social and physical foundation for higher level (scale) of urbanization. A neighborhood may be considered as an 'open system', with its all characteristics and rules. In any system, or any discipline, there are some kind of individual or unit, which is the smallest complete structure in that system and is the basis for the construction of any larger structures, such as the electron, virus, cell, plant, animal, man, family, firm, note, and so on. Each individual or unit exhibits behavior which relates it to the environment—that is, with other individuals with which it comes into contact or into some relationship.

The house may be considered as the smallest complete unit of a neighborhood. The residents of a house (the family) and all their activities and relationships outside and also with the physical structure of the house constitute the desired individual or unit in this case. This unit may be, of course further broken down into smaller units and components, the same way that an atom is broken down into electron and neutron. Such a decomposition, however, will not be of any use here. It is necessary here to make a utopian assumption that there is a direct relationship, as is used to be in the case of the preindustrial city, between the characteristics (value, needs, desires, etc.) of the inhabitants of the house and its physical structure. In other words, that the physical structure (size, form, style, color, materials, symbols, etc.) of the house is a direct and complete manifestation of different characteristics of those who live in the house. The house, according to this assumption, is a dynamic and living (organic) structure which evolves and changes in time to reflect the changes that occur in the inhabitant's value systems.

Using the analogy of linguistics, the house, as the smallest unit of neighborhood, may be compared with a 'word' (and not a letter, of course). Word is the smallest meaningful unit of a language, in the same way that house is the smallest meaningful unit of a neighborhood. Both word and house have their own independent meanings, based on their reasons for being. Bearing meaning means the transformation of information from point A, for example, to point B (see Fig. A.10).

A word, however, plays a very distinctive rule, along with other words, in constructing a 'sentence'. We are now beginning to make use of another integrative principle of urban design— the hierarchy principle. A sentence—a collection

Fig. A.10 Transmission of information for point *A* to *B*

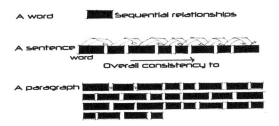

Fig. A.11 The three-level hierarchy of word, sentence paragraph (and text)

of several words based on some specific rules (grammar or syntax)—conveys a meaning (message) which, according to Gestalt principle, is greater than the sum of the individual meanings of words. Each word, through its meaning, helps the construction of the sentence. The meaning of the sentence, however, is independent of the meaning of individual words. It is obvious that the formation of the general meaning of a sentence depends not only on the independent meaning of each and every individual word, but also on a meaningful relationship between all the words in the sentence. These relationships should follow certain rules to be meaningful. In our linguistic analogy here, sentence may be considered to be equivalent to a 'block'. A block is a group of houses built next to each other with some interrelationships (socioeconomic, religious, cultural, etc.) based on certain rules and principles. A block, like a sentence, has its independent meaning, which is greater than the sum of the individual meanings of the comprising houses. Meanwhile, each house, through its meaning and on the basis of the certain rules adds to the construction of the general meaning of the block. This, as in the case of sentence, requires some kind of relationships between the individual houses. Lack of such a relationship between the individual houses will result in a gap which will eventually damage the whole meaning of the block, or the sentence.

A block built on the basis of certain rules and relationships between the units will undoubtedly be understandable to each member of the block, because each member has helped to the construction of the whole meaning and its meaning is part of the whole. Each unit contributes to the whole

meaning, although the whole is relatively independent of each individual member. The block is not a fixed, static and dead structure. It evolves, grows, and decays in time. People's values in each house changes in time and so do what they represent—symbols. This is a two-way relationship. Each member of the block contributes to the evolution of the block, but is also affected by such an evolutionary trend. The changes in the block are usually not very drastic. The block has its relative stability, continuity and consistency.

Sentences make the paragraph. Each sentence, it may be also said, bears meaning relatively independent of the paragraph. Each sentence, through the meaning it conveys, contributes to the construction of the general meaning of the paragraph, which again is greater than the sum of the meanings of all the individual sentences. A meaningful relationship between the sentences is again a prerequisite for the construction of a meaningful paragraph. Such a relationship should be based on certain commonly accepted rules and principles.

In the same way blocks construct a neighborhood (Figs. A.12 and A.13). The meaning (message) a neighborhood conveys is greater than the block. This meaning[8] is also more complete than the meaning of the block, individually and collectively. This hierarchical system moves toward perfection and self-sufficiency. They cumulate upward, and the emergence of qualities marks the degree of complexity of the conditions prevailing at a given level, as well as giving to that level its relative autonomy. The higher the level, the greater its variety of characteristics. A higher level cannot be reduced to the lower. According

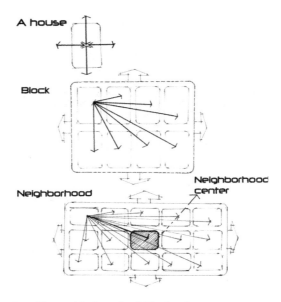

Fig. A.12 Three level hierarchy of house, block, and neighborhood

Fig. A.13 Conceptual sketches of house, block, and neighborhood

to the hierarchy principle, therefore, basic needs which are in demand more frequently than others may be provided at the neighborhood level, while specialized goods and services, may be provided at the city, regional or national levels. Hierarchical linguistic concepts may be further applied on a larger scale, such as to cities, metropolitan areas, regions, and so on. We will, however, limit our discussion here to the neighborhood level (Fig. A.11).

Although it was mentioned earlier that the meaning of a sentence or a paragraph is relatively independent of the meaning of individual words or sentences (in the case of a paragraph), exceptions, however, should be made to this

principle. There are certain words (or a group of words) in each sentence and certain sentences in each paragraph that bear an important and critical meaning and, therefore, play an essential role in constructing the general meaning of the sentence or paragraph. The words with such critical role are, in linguistic term, called 'deep structure'[9]. Since this concept has several strong implications for urban design practice, therefore, it will be discussed here in more details. Deep structure is that part (word) of a sentence, or a paragraph, which conveys most of the information, or meaning of a sentence or paragraph. The equivalent of deep structure in the block may be easily found, by looking for the elements in a sentence